SWANSEA
IN
50
BUILDINGS

GEOFF BROOKES

AMBERLEY

To our mothers, Eileen Brookes and Elaine Hopkin

First published 2018

Amberley Publishing, The Hill, Stroud
Gloucestershire GL5 4EP

www.amberley-books.com

Copyright © Geoff Brookes, 2018

The right of Geoff Brookes to be identified as the Author of this work has been asserted in
accordance with the Copyrights, Designs and Patents Act 1988.

Map contains Ordnance Survey data © Crown copyright and database right [2018]

All rights reserved. No part of this book may be reprinted or reproduced or utilised in any form or
by any electronic, mechanical or other means, now known or hereafter invented, including
photocopying and recording, or in any information storage or retrieval system, without the
permission in writing from the Publishers.

British Library Cataloguing in Publication Data.
A catalogue record for this book is available from the British Library.

ISBN 978 1 4456 8298 3 (print)
ISBN 978 1 4456 8299 0 (ebook)

Origination by Amberley Publishing.
Printed in Great Britain.

Contents

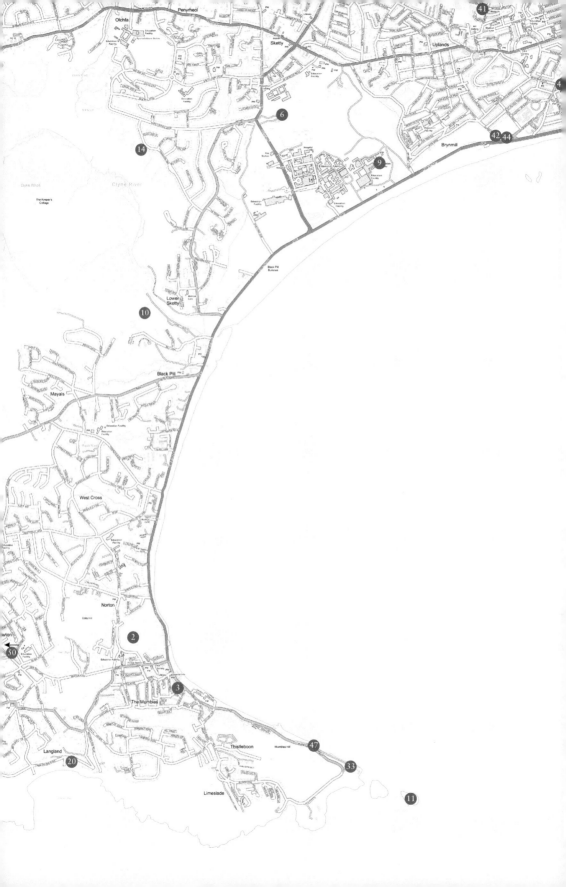

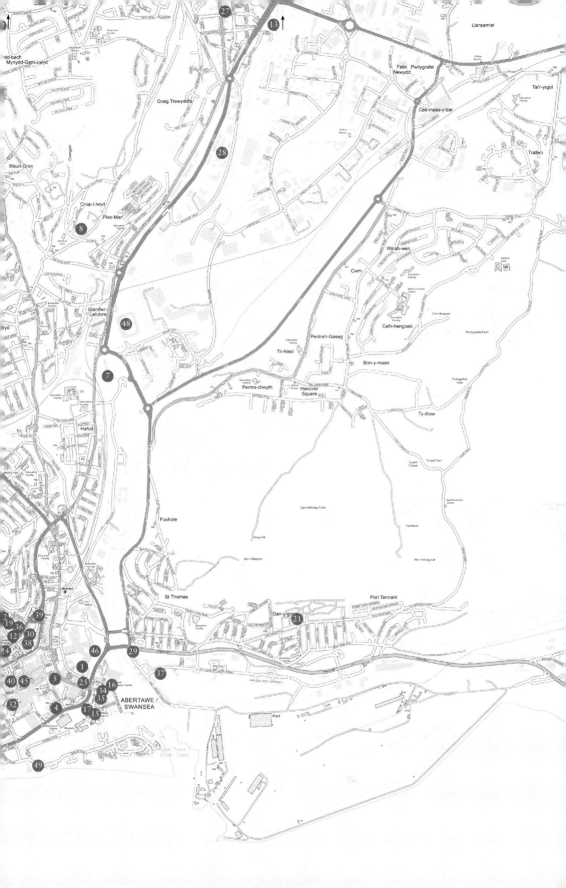

Key

Introduction

When Dylan Thomas said that Swansea 'has more layers than an onion and every one can reduce you to tears', he was not referring to its history, but rather to his emotional connection with his birthplace. However, it is an accurate expression of Swansea's past, for it has so many different layers, and this is illustrated perfectly in its architectural heritage, which represents our history in a physical form.

The chronological distribution of the buildings in the book reflects the rapid development of Swansea throughout the nineteenth century, but it all began much earlier than this. The name probably derives from 'Sweyn's Ea'. Sweyn was a Norse pirate, 'Ea' means 'island' and this was the place that he chose as his base. It is a layer of history about which we know very little, but whatever prosperity the settlement enjoyed, it was based upon its location and the sea, something that has never changed. The town only emerged into properly recorded history with the

Swansea, looking down from the Meridian Tower towards Kilvey Hill.

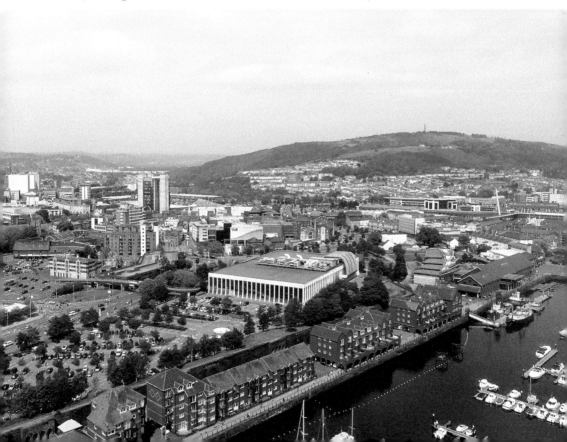

arrival of the Normans in 1099 and their colonisation of Wales. They established a division between town and country and between the Welsh and their rulers. It was a fracture that ran deep and persisted for centuries.

Swansea remained a quiet market town seeking protection from its castle for a long time, serving as just a small walled English port on a Welsh estuary. Again, we know very little about this period of history. You can see this in the list of the buildings in this book – for none still exist from this time.

It was industrialisation that had such a profound effect on Swansea, changing it forever. It began with the opening of the Cambrian Pottery in 1764. Although Swansea pottery is still much admired and collected, little survives of the places where it was created, because it was replaced by another more enduring layer, with the rapid expansion of the copper works along the river valley. Each ton of copper required at least 3 tons of coal to smelt it and so the ore was brought to where the fuel was plentiful. By 1823 there were nine copper works along the river. The fanciful dream of developing Swansea as a fashionable seaside resort disappeared forever.

At the start of the nineteenth century the population was around 6,000 but the numbers increased rapidly. It became a magnet for the rural poor and the dispossessed. Wealth was created, though not always shared, and the town became famous as 'Copperopolis'. Industrialisation changed Swansea – and also changed Wales – and when the copper industry ended a new layer settled upon Swansea: the tinplate works, which sustained the town into the new century.

The destruction of large areas of the old town in the Second World War led eventually to a new and vibrant layer of our history, aided by the transformation in the Swansea Valley and a remarkable change from filthy black to vibrant green. This idea of rebirth is shown in Swansea's relationship with its buildings, one based upon adaptation and regeneration. You can see this clearly as you navigate your way through this book, recognising how the city has started to add another layer to our history. These fifty buildings may not always be spectacular, but they represent the true nature of Swansea better than anything else.

The 50 Buildings

It still feels like the heart of the town, even if the world that surrounds it has changed. The fact that it seems overwhelmed by modern buildings was troubling residents as long ago as 1840. A letter to the *Cambria* referenced *Macbeth* when describing the castle as 'Cribbed, cabined and confined by narrow ways.' Today it still feels hemmed in. A great castle can confer importance on a town, but Swansea's was never a great castle and for much of recorded history it has been a ruin.

Swansea Castle.

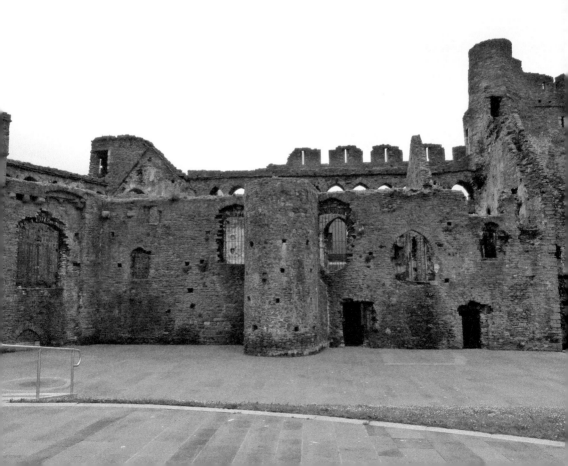

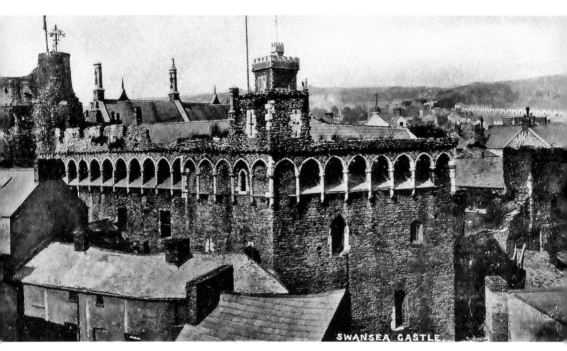

Postcard of a soot-encrusted Swansea Castle, posted September 1913.

It was built in an important strategic position on a hill with a steep drop down to the river, which you can still appreciate. The castle controlled the lowest crossing point on the river – the most important east–west route through South Wales – and the harbour.

The castle was probably built in 1106 by Henry de Beaumont and is first mentioned in the historical record when the original wooden building was attacked by the Welsh in 1116. Such was its fate. The first stone structure was erected after the original was destroyed once again by the Welsh in 1217. Nothing of that remains either. What we see today are the remains of the 'New Castle', dating from 1280 and reflecting domestic, rather than military, priorities.

The attractive parapet might have been designed by Henry de Gower, the 'Building Bishop' of St David's but no one knows. It might have been ransacked by Owain Glyndwr, it might have been dismantled by Oliver Cromwell, but no one can be sure about that either. Swansea has never been at the cutting edge of history; it was never anything other than a backwater. The castle probably fell into ruin all by itself.

The town hall was built in the courtyard and there was a dovecote too. The Great Hall became the Poor House and the Square Tower was the debtors prison until around 1858. The *South Wales Daily Post* had offices there that were bombed in the Blitz. Now it is an evocative empty shell.

The faintly disparaging description by the *Cardiff Times* in 1909 as 'first a fortress, then a gaol and then a pigeon-house' is probably about right.

2. Oystermouth Castle, 1107

Like Swansea Castle, Oystermouth is Norman and, also like Swansea, the most dramatic periods of its history came in its earliest years. It has a fine position on high ground and an original timber structure seems to have been built in 1107, allowing the Welsh to burn it down at least twice before a more substantial version was erected in 1220. They burnt that down too.

It was rebuilt around thirty years later and was regarded as an impressive residence – fit for a king indeed, which was just as well since Edward I stayed in it in December 1284. A large chapel was added and the castle was always ready for a siege, a level of planning reflected in its impressive catering arrangements. We are told that 'the hearth in the kitchen is very large, and would almost permit a whole bullock to be roasted at once'. However, the Welsh found different castles to burn and moved on.

By the sixteenth century it had become a picturesque ruin. Parts of the castle were adapted as cottages and the gatehouse also became a domestic residence, in spite of persistent rumours of a resident ghost. The great actor Edmund Kean stayed there in 1809 in order to confront a spectre that sadly proved to be merely one of his pals wrapped in a sheet.

Nineteenth-century historians were desperate to believe that Cromwell took a dislike to Oystermouth Castle and shelled it vigorously from Colt's Hill close by, but it is far more likely that he ignored it completely. In 1650 a review of Gower described it as 'an old decayed castle being for the present of no use but of a very pleasant situation and near unto the seaside'. Mumbles residents valued it most as a picnic site, enjoying the special romantic atmosphere that always accompanies a ruined castle.

Oystermouth Castle. (Reproduced with kind permission of David Brookes)

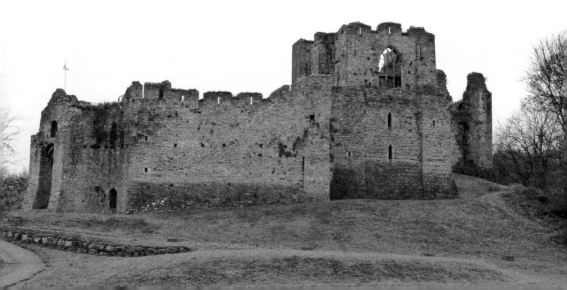

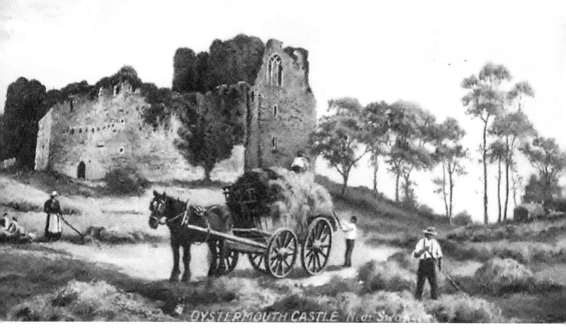

Undated postcard of Oystermouth Castle.

Renovation work in the twentieth century has ensured the castle's continued appeal. It is occasionally used as an outdoor theatre and there are now summer activities, like medieval-themed days. There has also been the fine addition of a glass bridge, which makes a wonderful viewing point. Oystermouth Castle lives on.

3. All Saints Church, Oystermouth, 1141

The sea is woven into the tapestry of the city's history. On good days, when the bay is calm and beautiful, it has brought opportunity, employment and wealth. However, those things have always been accompanied by tragedy and the place that best remembers the terrible price that is sometimes paid is All Saints Church in Oystermouth.

The church faces out to sea from its prominent position on high ground overlooking the village and has a long history. The earliest record of a church standing on this site is 1141 and it contains some extremely old elements such as the medieval font, which might date to 1251. However, the fabric of the church as we see it today was significantly remodelled during the nineteenth century.

Outside against the wall there is the gravestone of William Jenkins, a lifeboat man who died during the Admiral Prinz Adalbert rescue in 1883, but it is inside, in the marvellous stained-glass windows, that the most treasured memorials to the Mumbles lifeboat crew are to be found.

In the north aisle memorial windows were installed, perhaps in 1915. One features the image of Christ walking on water to honour the four men, including Jenkins, who died in 1883. Another window shows the story of the loaves and the

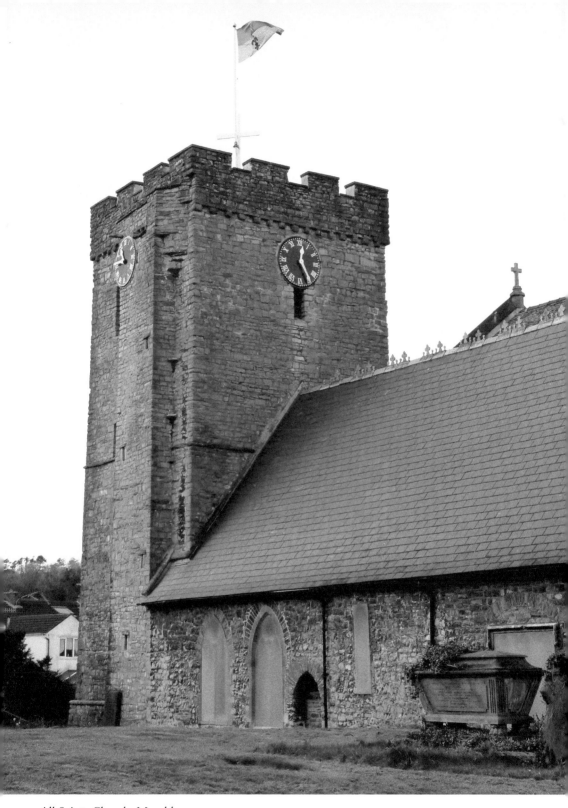

All Saints Church, Mumbles.

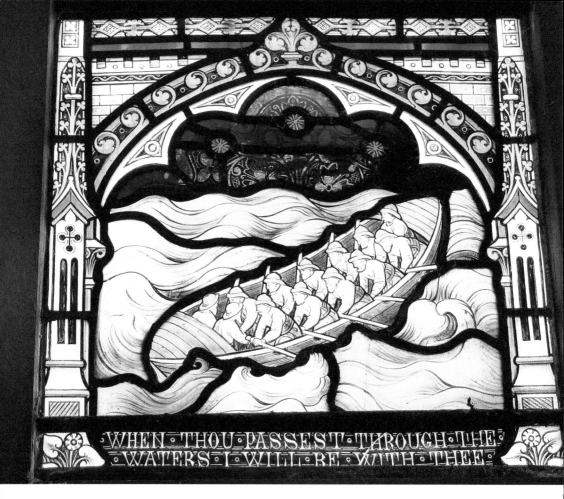

WHEN · THOU · PASSEST · THROUGH · THE WATERS · I · WILL · BE · WITH · THEE

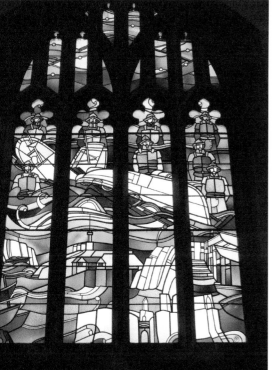

Above: Detail from the window remembering those lost in 1883.

Left: The Mumbles Lifeboat Window by Tim Lewis.

fishes beneath which there is a brass plaque that remembers six crew members who died off Port Talbot when the lifeboat capsized in 1903.

However, it is the impressive Mumbles Lifeboat Window, designed by Tim Lewis and installed in 1977, that many visitors come to see. It commemorates the Samtampa disaster in 1947 when all eight members of the lifeboat crew were lost. They left Mumbles in a storm to assist the SS *Samtampa*, which was having serious difficulties off Porthcawl. The *Edward Prince of Wales*, the station's first motorised boat and in service since 1924, was overwhelmed in heavy seas. The crew of the *Samtampa* also perished.

The window with the overturned lifeboat surrounded by the eight lost crew members will surely remind you of the moving words of 'For those in peril on the sea.' There is nowhere else in Swansea where those words are more real than in All Saints Church.

4. St Mary's Church, 1291

The 'Church of the blessed Marye of Sweyns' has always been the most important church in Swansea and provides a reminder of the original shape of the town. The castle was at one end of the settlement on a defensive mound and the church was at the other. That church has always been there, though it has changed and evolved over the centuries since it was first referred to in 1291.

St Mary's Church, Swansea.

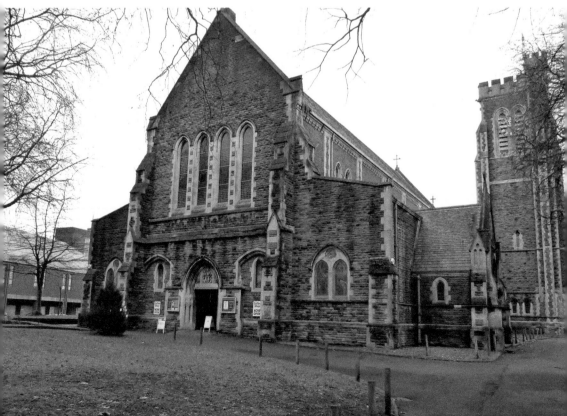

St Mary's remained intact for over 400 years, surviving the Reformation and the Civil War. However, there were significant structural weakness in the medieval building and they certainly contributed to the dramatic collapse of the nave on a Sunday morning in 1739, moments before the waiting congregation had entered. The church was rebuilt and then renovated in 1882 when the slums alongside the church in Frog Street and Cross Street were cleared.

It was then taken down and rebuilt in 1896 and enjoyed a brief respite before the German bombers came in 1941 and reduced it to a smoking shell. It lost most of its treasures, including a painting by Sassoferrato, bequeathed by Thomas Bowdler, who had published expurgated editions of Shakespeare's work.

When the Queen Mother came to Swansea for the rededication service for St Mary's in 1959, it was a moment that carried huge symbolic weight, for the new church was a reconstruction of the destroyed version and as such represented the resurrection of the town. The excellent stained-glass window above the porch, across which the red stain of fire spreads, still reminds us of the destruction from which the contemporary building has sprung.

The oldest surviving artefact in St Mary's lies beneath a carpet to the left of the altar. This black marble stone once covered the grave of Sir Hugh Johnnys, who was Knight Marshal of England and died in 1485. Outside you can find the fading

Stained glass in memory of the Three Day Blitz, 1942.

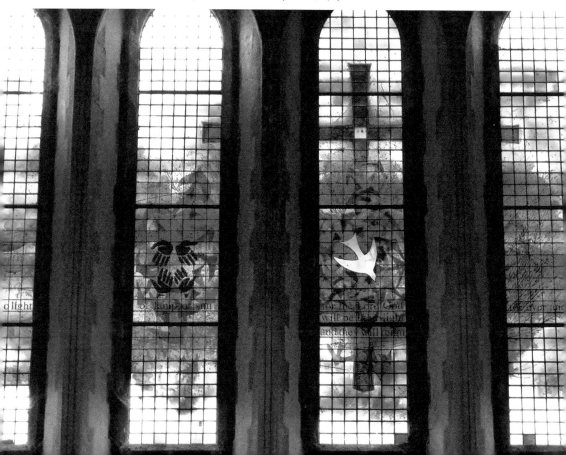

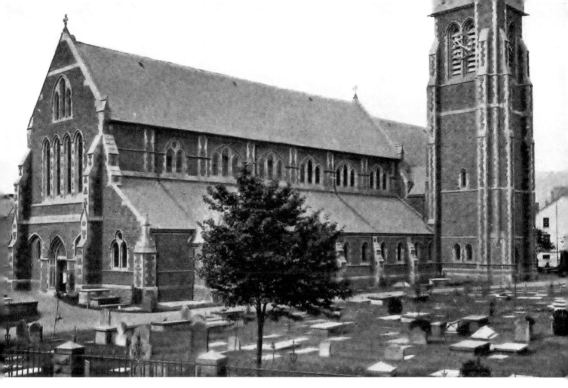

St Mary's Church (postcard dated April 1919).

gravestone of William Jernegan, the architect, now used as a paving stone, and the more ornate tombstone of Major Rotely, who fought at Trafalgar and claimed to own the breeches that Nelson wore on the day he was shot on board *Victory*.

5. Cross Keys Inn, 1332

The Cross Keys Inn on Princess Way is the only medieval building still visible in Swansea, other than the castle a short distance away.

The rear of the building incorporates the remains of the Hospital of the Blessed David. It was an almshouse built by Henry de Gower, Bishop of St David's, in 1332, housing six working clergymen and 'other poor chaplains and laymen deprived of bodily health'.

Three original fourteenth-century windows can still be seen at the back, two of which are on the first floor and one is at ground level. Some particularly hefty foundations were once uncovered and there is a suggestion that parts of the original roof trusses remain too. There might once have been an open courtyard where the more mobile residents are believed to have brewed mead and made butter.

Following the Dissolution of the Monasteries the building was given to Swansea's Herbert family. Extensive alterations in 1650 created the Cross Keys Inn, which is the basis of the attractive public house that we can see today, the oldest one in Swansea. It has been much restored but there are plenty of timber beams inside to maintain a welcome air of antiquity.

The Cross Keys Inn.

Unfortunately the Cross Keys developed a racy reputation during the latter part of the nineteenth century. In July 1886 James Frayne the landlord was fined £5 for harbouring prostitutes on his premises, 'the resort of men and women of bad character'. Apparently in a three-and-a-half-hour period forty-five women entered the house. The police only withdrew their objection to the renewal of the Cross Key's licence when they were reassured that the landlord was to be replaced. Unfortunately things did not get any better with Frank Thomas. He was summoned and fined after Sergeant Gardner found four women of ill-repute standing at the bar. The unsuccessful defence case was that the nature of the neighbourhood was such that no one else would ever drink there.

It goes without saying that today's customers repudiate such a seedy reputation. As Swansea residents they are entirely beyond reproach. I know because they told me so.

6. Sketty Hall, 1720

This Georgian mansion, occupying a fine site overlooking Swansea Bay, has always been one of the most important residential buildings in Swansea.

The oldest part of the house was built in the 1720s and for most of its history it was always a family home. In February 1806, when it was to be sold at auction in London, it was described as 'an elegant residence for a genteel family' with 'an

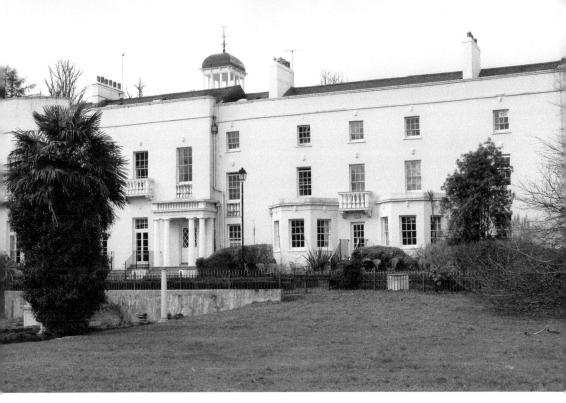

The rear of Sketty Hall.

eligible suite of apartments with every requisite internal convenience, fitted up in the modern stile'.

For a while it was in the possession of Charles Baring, a famous merchant banker. He added a new floor to the building. In 1830 when he put the contents of the house up for sale it included 'a mahogany telescope, furniture and a hundred dozen of choice wines'. Lewis Weston Dillwyn, the owner of the Cambrian Pottery in Swansea, came next. He wrote in his diary in June 1831 that 'all the family were so crazily in love with Sketty Hall that I wrote this evening and offered £3,800 for it and the fixtures'. He added the entrance hall and both a hothouse and an icehouse.

The dining room was added by the next residents, the Yeo family, who turned it into an occasional venue for amateur theatrical performances.

Richard Glynn Vivian, of the wealthy copper manufacturers, returned from London in 1898 and bought Sketty Hall. He had spent his childhood a short distance away in the Vivian home in Singleton Abbey and regarded Sketty Hall as 'the home of my age'. He housed his art treasures there, which formed the heart of the collection in the Glynn Vivian Art Gallery.

He made some alterations to the façade and developed a lovely formal Italianate garden, which is still enjoyed today. Just before his death in 1910 he said, 'With what pleasure have I tried to beautify that dear house, inside and out.' He had every reason to be proud of what he achieved.

Sketty Hall was restored in 1994 and is currently managed by Gower College. It is a place for formal dinners and conferences and it is a popular wedding venue.

Old Gates.
From a Convent in France
1904
After Nuns & Monks were Expelled

At the entrance to Sketty Hall.

7. The Lower Swansea Valley Copper Works, 1737

There can be no doubt that copper transformed Swansea, its remarkable growth making the town a key location in the British Industrial Revolution. By 1820 over half of the copper smelted in the world came from here. The factories clustered along the river brought wealth to some, work – and sickness – to many, and an environmental catastrophe to the valley.

It developed because the town had considerable advantages. It had easy access to the sea and there was plenty of coal so it was cheap to bring the copper here to be smelted. With good reason, Swansea became known as 'Copperopolis'.

The White Rock Works, established in 1737, were on the eastern side of the river and the remains are now largely buried under grass beneath Kilvey Hill. Further upstream, and now enveloped by a new housing development, you will find the last fragment of the Upper Bank Copper Works, the smelting shed where the copper goods were produced, which helped to fund the slave trade.

It is when you visit the Industrial Archaeology Park on the west side of the Tawe in Hafod, where you can wander freely among the ruins, that you get a real idea of the extent of the enterprise. The Morfa Copper Works began in 1828 on the site, which has become the Landore Park and Ride. The rolling mill, which now houses the Swansea Museum Collections Service, was at one time the largest building of its type in the world. The sadly decayed canteen building with the distinctive remnants of a clock tower is at the bottom of the site where the buses wait.

Across the road are the ruins of their rivals, the Hafod Copper Works, established in 1810 by the Vivian family. The two concerns were bitter rivals and it is said that employees of the two companies were forbidden to talk to each other

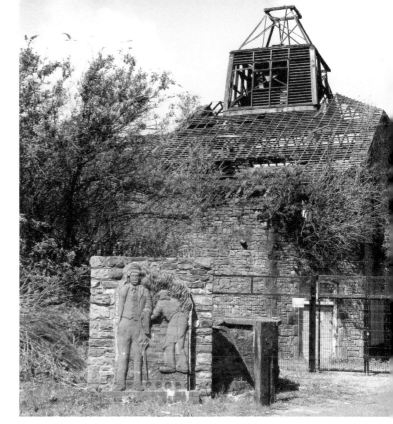

Right: The Canteen Building at the Morfa Works.

Below: In the Hafod Copper Works.

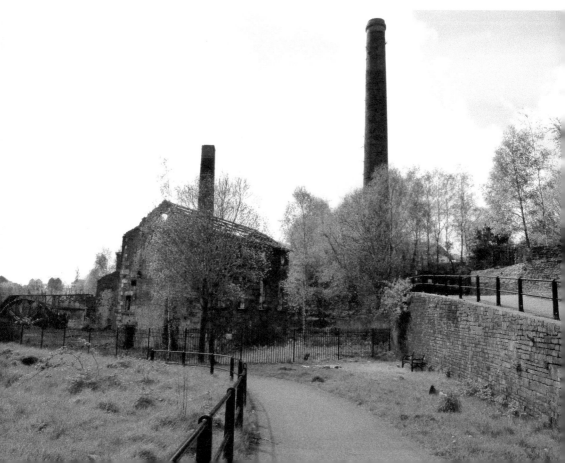

At the Industrial
Archaeology Park.

for fear of leaking industrial secrets. Here you can see the two engine houses that helped to power the mills and their chimneys, the final reminders of the myriad of belching columns that once filled the lower Swansea Valley.

This fascinating site with its informative displays provides easy access for everyone.

8. Morris Castle, 1773

On 29 August 1773 the first rents were paid by the residents of 'Morris Castle'. This is now the iconic ruin standing above Landore, today a designated Ancient Monument, because it was probably the first high-rise block of workers' flats in the modern world.

The castle was built by John Morris, an industrialist who inherited the Forest Copper Works from his father, to provide housing for his workers, although it is interesting to note that the original residents were brought in by Morris as strike-breakers from Pembrokeshire, apart from a tailor and a shoemaker who were regarded as 'useful appendages to the fraternity'.

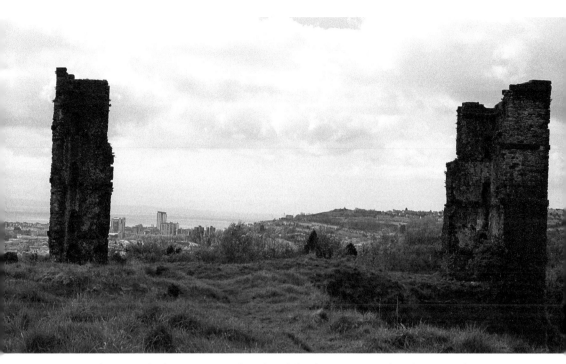

Morris Castle, towards the sea. (Reproduced with kind permission of Melanie Heath)

The structure was always called a castle because it was topped by false battlements made of copper slag. It was built around a central courtyard with a square tower of four floors at each corner. The towers were linked by three-storey blocks, which contained an internal quadrangle. It is likely that twenty-four families lived there.

When it was built it was not as remote as it now appears. There were lots of cottages up there but the castle was never popular, despite such refinements as a form of central heating and centralised refuse disposal, using chutes from the upper floors that emptied into a large container. There was a significant problem with the lack of access to water, which had to be carried up the hill and then up the stairs. Earth banks behind the building suggest that occupants may at least have had their own vegetable patches.

The last inhabitant is known to have vacated the premises in 1865, although mining nearby had made the castle unstable long before that. Stone used for Morris Castle was taken to build nearby cottages and quarrying of underlying sandstone caused the collapse of two towers. Only the end walls of the north-east and west towers still stand. The sockets for wooden beams and windows are clearly visible.

In 1870 a guidebook to Swansea stated that the castle was entirely unsuccessful 'because no families in their right senses would clamber up and down stairs to live above and below each other', but the concept of providing workers housing was sustained in the development of terraced housing, especially in the Hafod.

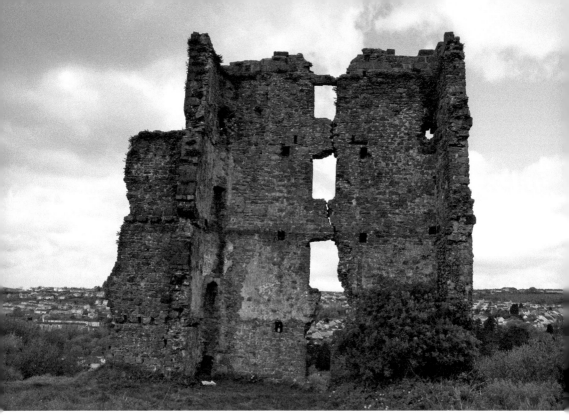

Morris Castle. (Reproduced with kind permission of Melanie Heath)

9. Singleton Abbey, 1784

Let's get one thing clear: it was never an abbey. It might have looked like one but it was never actually an abbey. It was originally called Marino and was built in 1784 for Edward King, the collector of customs in Swansea. It was an octagonal villa based on the designs of the Swansea architect William Jernegan, and you can find it on the north-eastern side of Singleton Park, on the road to Mumbles.

The story of the building that we see began in 1817 when it was bought by John Henry Vivian as the main residence for the family at the heart of the development of the copper industry, which had such a transformational effect on Swansea. The house was then enlarged over a number of years in the style of a Tudor country house and was renamed Singleton Abbey in an attempt to confer upon it an ancient dignity to enhance the family's newly acquired status.

In its time it welcomed guests such as the Prince of Wales in 1881 (later Edward VII) and William Gladstone in 1886. However, it was seriously damaged by a fire in 1896, which started in the laundry in the basement of the north wing. The family were saved by the barking of a pet terrier and the house was saved by the 'extreme energy of the Swansea Fire Brigade'. In 1887 *Cambrian* newspaper had reported that 'suits of armour line the walls, which are further adorned with crossbows, battle-axes, javelins, and a scythe from the Irish rebellion. Amongst the curiosities

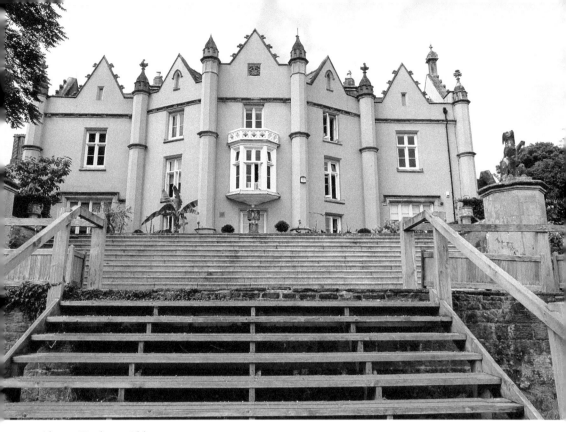

Above: Singleton Abbey.

Below: Nineteenth-century postcard of Singleton Abbey. (Reproduced from David Taylor's collection with the kind permission)

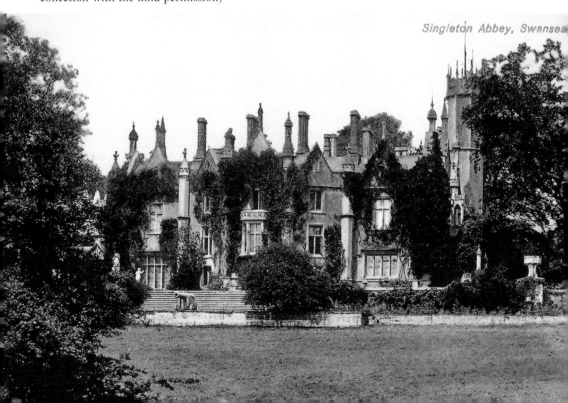

Singleton Abbey, Swansea

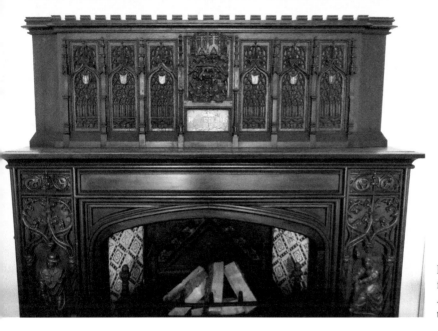

Possibly a panel from Catherine of Aragon's wedding trousseau.

are a seal killed at the Mumbles Head and an old chair from the inquisition chamber at Venice.' Alas, such joys disappeared in the flames. The residence was rebuilt but the family preferred to relocate to London.

Singleton Abbey was eventually sold to Swansea Corporation, who, in turn, sold the estate in 1923 to the University College of Swansea. It now houses the administrative offices where the staff can still enjoy an elegant working environment. Most of the original furniture and decoration were disposed of when the building was sold, though it still, allegedly, retains a panel from Catherine of Aragon's wedding trousseau, which is displayed above a fireplace.

10. Clyne Castle, 1791

'Woodlands' was built in 1791 for the Carmarthenshire businessman Richard Phillips and was given the title of castle by its next owner Colonel Warde in 1799. It underwent serious remodelling in 1819 from which it emerged as Clyne Castle and eventually passed into the possession of the Vivian family in 1860. When it became the home of William Graham Vivian, the development of its picturesque gardens began. They are a remarkably impressive ornamental space, which is still enjoyed, especially in May when more than 800 rhododendrons are in glorious bloom.

The estate passed to his nephew Algernon Walker-Heneage-Vivian, known as 'The Admiral', in 1921, who owned it until his death in 1952, after which in 1954 the gardens were opened as a park.

There is so much to see here, like the chapel, which was built by Graham Vivian in 1908 with medieval and renaissance features brought from overseas, or the Gazebo where the admiral could watch the ships in the bay. The Japanese garden and the artificial lake are beautiful. There is a crenelated clock tower, a viewing

Above: Clyne Castle.

Below: By Holder Mathias Architects, within the grounds of Clyne Castle.

tower and what is known as The Ivy Tower which was, in fact, a chimney for the Clyne Valley Arsenic and Copper Smelting Works – the skull beneath the skin of woodlands which also provided cover for shoots. Here in December 1904 a shooting party killed 579 pheasants.

The castle served time as student accommodation with some of the impressive interior features preserved, before it was converted into apartments, some of which are blessed with access to their very own turrets.

Other student accommodation blocks in the grounds were demolished and in a curve that fringes the north side of the castle fifteen remarkable houses have been built. It is an arresting development of white futuristic houses looking down to the sea, which manages to sit perfectly with the grey self-importance of the castle. They were designed by Holder Mathias Architects, who are justifiable proud of their achievements.

Clyne Gardens is never locked but the grounds of the castle are, with the entrance into the estate secured against the unwelcome.

11. Mumbles Lighthouse, 1794

In July 1792 work began to build a lighthouse on the Mumbles headland. It was badly needed. The Cherrystone Rocks and the Mixon shoals, around half a mile offshore, form two huge and dangerous underwater obstructions. In October the incomplete structure collapsed, so William Jernegan, the architect who designed much of Georgian Swansea, took over the project, and the lighthouse was finally completed and lit in 1794.

It was constructed of stone and formed a tower with a smaller octagon on top of a larger one. The following year, a house was completed on the island 'for the

Mumbles Lighthouse.

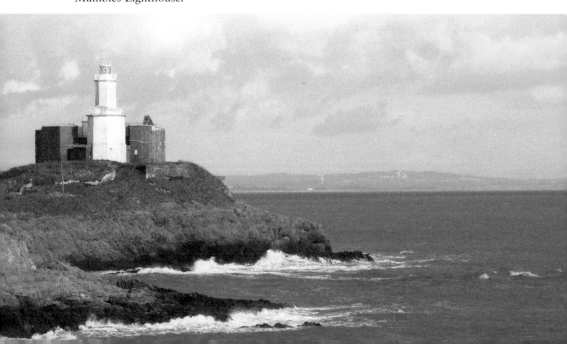

keeper of the light'. The small island eventually housed a battery or fort to protect Swansea against a French invasion, plus a telegraph station, and was eventually occupied by fourteen people, including the families of both the lighthouse keeper and assorted military personnel.

Initially it displayed two open coal fire lights one above the other to distinguish it from other lighthouses as an aid to navigation. However, the coal lights in braziers were expensive and difficult to maintain, so in 1798 the lighting was converted to a cast-iron and glass lantern.

It is still operational, still lighting the darkness and still something about which Swansea is very proud.

12. The Laurels, 1811

Swansea's modern police station is built on the site of the earlier fire station on Alexandra Road opposite the Magistrates' Court. It does not have the grace of the original police station a short distance away, but it does have a gleaming and distinctive curved blue facing – a modern alternative to a Blue Lamp. There is also a splendid sculpture of a finger print by Andy Hazel, outlining features in the history of the police force.

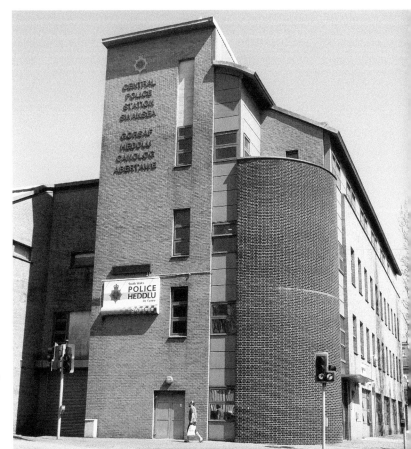

Central Police Station, Swansea.

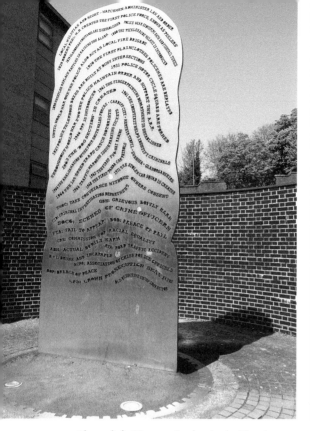

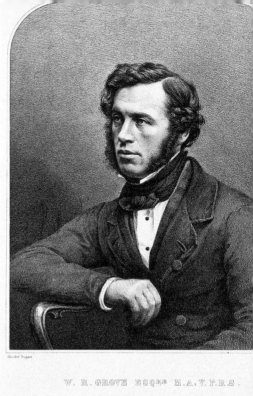

Above left: Fingerprint by Andy Hazel.

Above right: William Grove. (Photograph reproduced with the kind permission of the Wellcome Collection)

Splendid though it is, this is not the only feature of interest. On the wall you will find a blue plaque remembering one of Swansea's most significant residents, a man born in a house called The Laurels on this site in 1811. This is William Grove, who has touched all our lives, for he invented the battery.

William, whose father was a magistrate and deputy lieutenant of Glamorgan, attended Swansea Grammar School and then Brasenose College in Oxford where he studied law. However, he was initially unable to begin his legal career due to ill health and so returned to Swansea where he devoted his time to his greatest passion – science. He became absorbed in electrical research and in 1839 developed the voltaic battery, which generated electricity from zinc and platinum, each suspended in different acids. This went on to power early telegraph systems, although the batteries had the unfortunate side effect of discharging poisonous nitrogen dioxide. He became professor of Experimental Philosophy at the London Institution and developed an international reputation as a result of his essay 'The Correlation of Physical Forces' in 1846.

In his legal career he developed an interest in patent cases, though he was said to be 'over-interested in the scientific aspects' and would prefer to suggest improvements to the patent rather than offer advice on legal issues.

He became a judge in 1871 and received a knighthood in 1872. He was also a member of the Metropolitan Commission on Sewers. However, his most remarkable achievements were in science and an obituary written on his death in 1896 suggested that, given his time again, he would have studied science rather than law. 'Science would have gained much more than the law would have lost.'

13. The Engine House, Scott's Pit, 1817

On Gwernllwynchwyth Road in Birchgrove there is a striking reminder of Swansea's coal industry: Scott's Pit Engine House. This impressive stone building once contained a Cornish beam engine used to pump water from workings in what was known as the Venture Pit, which worked the Church or 4-foot coal seam 160 yards below. The engine was one of the first of its type in South Wales. A large Haystack boiler would provide the energy to remove the water from what was an extremely 'wet' pit.

The pit was financed by John Scott, a London solicitor and speculator, and was sunk between 1816 and 1819. He also built a tram road to take the coal down to the White Rock Copper Works and to a wharf there. Initially steam power was used and it is said that George Stephenson himself sold him an engine and was present for the opening. However, the engines proved unreliable and were soon replaced by horses.

Scott eventually sold the pit in 1828 to Charles Smith, a local coal owner who worked it until around 1842. It stood derelict until it was reopened in 1872 for use as a shaft to ventilate and drain the Cae Pridd Pit. It was finally closed in 1930. The shaft is now capped in concrete.

The Engine House, Scott's Pit.

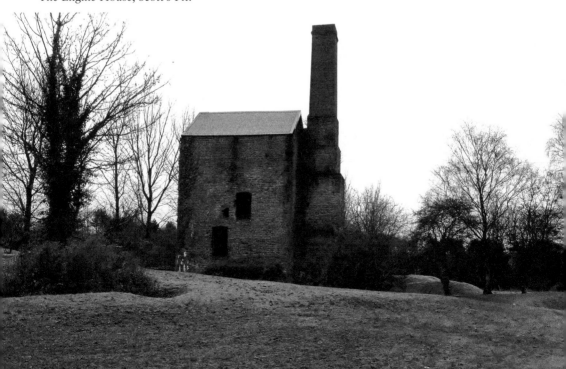

14. The Belvedere, 1820

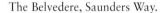

This building is called the Belvedere, though it would be more accurate to describe it as an ornamental garden feature – or a folly. It stands on a tree-covered mound on Saunders Way in Sketty Park and it is notable because it is the only surviving fragment of one of Swansea's lost houses: Sketty Park House.

It was the home of the Morris family who created Morriston and Morris Castle. They came from Shropshire and established the Forest Copper Works in the eighteenth century. They built themselves a grand house called Clasemont, near to where the DVLA is today.

However, Sir John Morris found the outfall from his own smelting works rather intrusive and so he had Clasemont deconstructed in 1805 and rebuilt in Sketty, considerably upwind of his own pollution, under the direction of the architect William Jernegan. The estate was noted for a long history of conflict with local poachers. Towards the end of the nineteenth century the house was used as lodgings for judges presiding at the local assizes.

It was eventually demolished in 1975, although the Belvedere, perhaps built in 1820, still remains. Once it was a castle fit for a princess for generations of children, but now it is a place where horseshoe bats roost.

The Belvedere, Saunders Way.

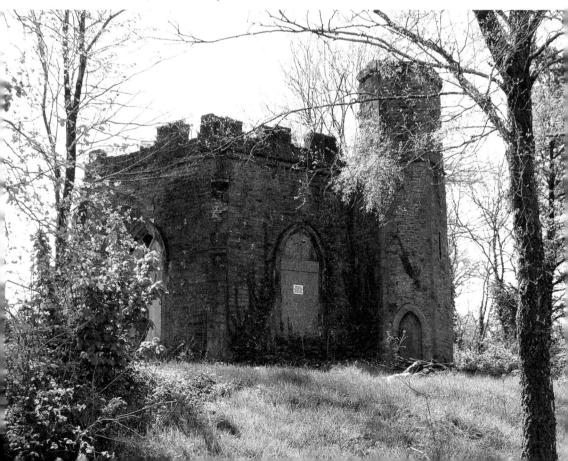

15. Gloucester Place, 1827

In December 1827 a tempting advertisement appeared in *The Cambrian* newspaper for a 'Newly erected and modern-built dwelling house, No. 2 Gloucester Place, replete with conveniences and built of the best materials' and offering 'extensive views of Swansea Bay' – a shrewd investment in the most attractive part of central Swansea.

Gloucester Place, situated behind the Royal Institution, is a very good example of a late Georgian terrace, with those perfect sash windows creating an elegant unity. It also has a fascinating history.

On the corner there is the Queen's Hotel, the site of a legendary nineteenth-century brothel. At one time the entrance of the hotel was guarded by a stuffed bear. At the far end there is St Nicholas' Seamen's Mission, which opened in 1865 and has been

The site of the Gloucester Hotel, Gloucester Place.

converted into an art gallery. Opposite you can find the Dylan Thomas Theatre, a community theatre that opened as the Little Theatre in Mumbles in 1924.

Next door was once the Gloucester Hotel, and in April 1889 the publican Frederick Kent was murdered with a razor by Thomas Allen, who was hiding beneath his bed. Allen was in fact a travelling shoemaker called Leon Pinzulu and he was hanged in a botched execution in Swansea gaol.

16. The Dylan Thomas Centre, 1829

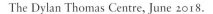

The Dylan Thomas Centre in Somerset Place has had a varied history – a story of regeneration and rebirth.

The original town hall next to the castle had not been big enough and so a new building was constructed on open land in the Burrows, where there was considerable development in Georgian times. It opened in 1829 and original sketches show an elegant building with a double flight of stairs leading up to the main entrance on the first floor.

The Dylan Thomas Centre, June 2018.

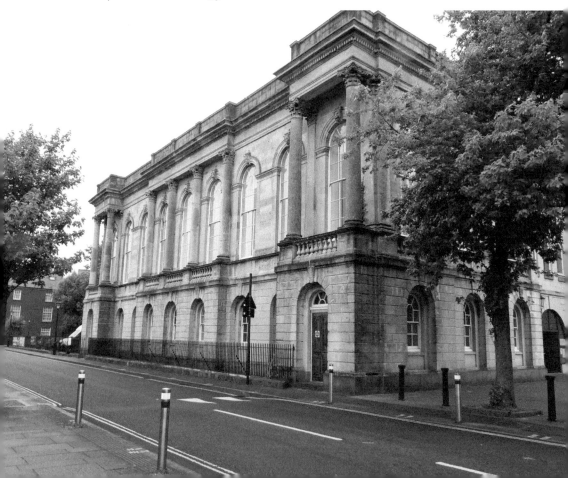

However, as the town continued to grow, it was realised that the building still wasn't big enough. It was enlarged and redesigned in 1852 in the form which we would recognise ourselves, though it has now lost the Russian cannons captured in the Crimean War, which were once parked in the courtyard.

It was the centre of civic life: the courts were there along with various important offices but it was found wanting once more. Judges at the assizes started to complain regularly about the accommodation and specifically about the noise, which sometimes undermined the dignity of their deliberations. In June 1897 Justice Ridley warned the captain of a vessel in the North Dock that he would be charged with contempt of court if he didn't stop discharging steam very loudly and disrupting the proceedings.

Talk began about a replacement, because, after all, a thriving town like Swansea deserved something grander. Of course these things take time and it wasn't until 1934 that the Guildhall was opened in Victoria Park.

The old Guildhall became a Youth Employment Bureau and another part of the building became firstly Swansea Technical School, then the College of Further Education and finally an annexe to Dynevor School until the building closed in 1982.

For ten years it remained abandoned until, following refurbishment, it became Ty Llên, the House of Literature, in 1995, when Swansea was chosen to host the UK Year of Literature, and was officially reopened by former American President Jimmy Carter. Today it is known as the Dylan Thomas Centre and runs a varied arts and literature programme and has an impressive permanent exhibition, 'Love the Words', which tells the story of the poet's life and work.

Undated postcard of Swansea Town Hall, with the Crimean cannons.

TOWN HALL, SWANSEA

17. Swansea Museum, 1841

The story of this museum begins with the Swansea Philosophical and Literary Society. It was founded in 1835 by a number of local scientists and historians keen to share and extend their knowledge and to make Swansea a centre of culture and scientific research. In 1838 Queen Victoria consented to be their patroness and it became known as the Royal Institution of South Wales, the oldest cultural society of its kind in Wales. It was the Royal Institution that founded and built what is now Swansea Museum.

The original society had opened a small museum in the summer of 1835 in rooms in Castle Square, but for the press it presented 'but little of novelty to attract or interest the scientific visitor'.

The RISW built the present Swansea Museum building in 1841, the earliest purpose-built museum in Wales – with exhibition galleries and also a library, a laboratory and a lecture theatre – dedicated to 'the moral and intellectual improvement of the human mind'. In keeping with this mission, it is a dignified building with a neoclassical design – a temple to learning – with four columns supporting a fine pediment.

Swansea Museum.

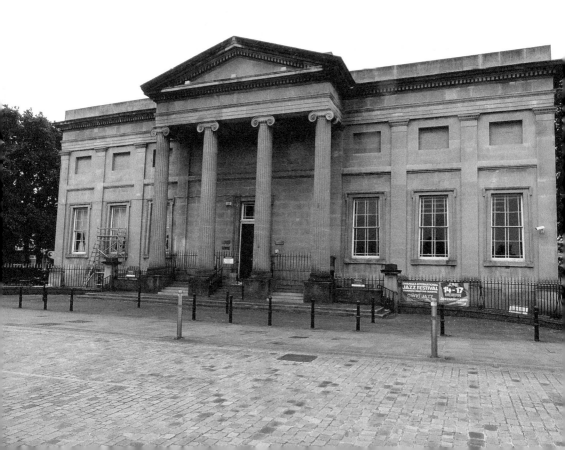

They were very proud of what had been built and appointed Hugh Mahony as museum keeper and caretaker. He was given apartments in the cellar, 'with coals and candles, and a salary of £1 per week', where he lived with his wife and three daughters. Sadly in 1851 he was dismissed for financial irregularities.

It has preserved Swansea's heritage ever since, with a particularly good display of Swansea pottery. The most popular exhibit, however, is still the mummy of the Egyptian priest Hor, which was donated by Lord Francis Grenfell of St Thomas in 1888 after serving as Commander-in-Chief of the British Army in Egypt.

The Royal Institution owned and managed Swansea Museum for nearly 140 years. Now part of the Museums Service of Swansea City Council, it still stands on Victoria Street looking down towards Quay Parade, a proud symbol of Swansea's history, greeting visitors as they enter the town from Fabian Way. During the Blitz of February 1941, a bomb landed in the library but did not explode, an appropriate symbol of the indestructible spirit of Swansea.

18. The Equatorial Observatory, 1846

The Equatorial Observatory is a Scheduled Ancient Monument. It has an original brick and stone base, with a circular telescope chamber on top and an adjacent laboratory. It is the second oldest observatory in Wales and was built by John Dillwyn Llewelyn, perhaps in 1846, and it is the only structure that remains from Penllergare House, which was demolished by explosives in 1961. It was in

The Equatorial Observatory.

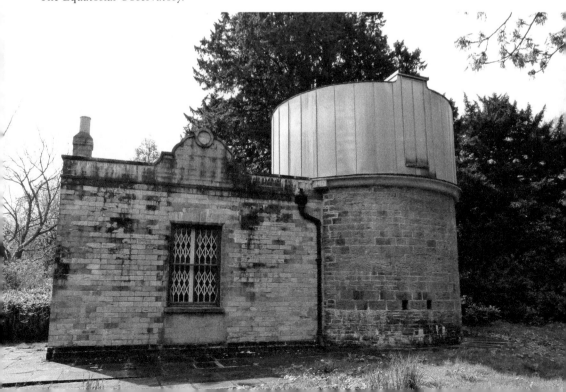

this observatory, together with his daughter Thereza, that he took one of the very earliest photographs of the moon in 1856. I have seen it and, if I am honest, the moon looks much the same as it does today, but then I am no astronomer.

The observatory is all that remains of one of the most important lost estates of Wales. Through marriage the Dillwyn family, owners of the Cambrian Pottery, acquired the Penllergare estate from the Llewelyns, agreeing to tie their two surnames together. John Dillwyn-Llewelyn (1810–82) was an astronomer and enthusiastic amateur scientist. He arranged for waste steam to be recycled to reheat the house, ran boats powered by electricity on the estate's lakes and experimented with the creation of underwater cables, successfully submerging an insulated telegraphy line from a boat to Mumbles lighthouse.

His wife Emma was a cousin of the important photographic pioneer Henry Fox Talbot and he shared this enthusiasm, taking many important early pictures of the estate. A collection of his work is now in the possession of Swansea Museum, including a photograph of the moon.

He also made considerable changes to the estate. Our view of it is clouded by the proximity of the M4, which ripped through part of it, but to his contemporaries, Penllergare House was 'a commodious building of two stories, commanding extensive views from all sides, embracing rock, wood, water, hill and dale, and rich pasture land'. It was a Victorian paradise, 'one of the finest sites for natural beauty that could be found in the county of Glamorgan'.

Sadly, Penllergare was forgotten and fell into considerable neglect. However, its faintly beating heart was never completely extinguished. The admirable Penllergare Trust is devoted to rescuing this significant part of our history and deserves our support.

19. Swansea Grammar School, 1853

The old Swansea Grammar School building is rather overwhelmed today by the more functional buildings of Swansea Metropolitan University that surround it, but it is all that remains of an institution that has had a number of locations over the centuries.

It was originally founded in September 1682 by Hugh Gore, the Bishop of Waterford, who had once served as the rector of Oxwich, 'for the love that he beareth to the Towne of Swanzey'. The school originally occupied a site on Goat Street, now part of Princess Way. It did close for a time after 1842 but then reopened on a new site in Mount Pleasant in September 1853, complete with a tower, which served as a noted landmark. The extension built in 1869 is what we can see following severe damage by incendiary bombs in the Blitz of 1941.

It is a fine building that has now been refurbished and extended to provide office space and student accommodation and still retains some original vaulted ceilings.

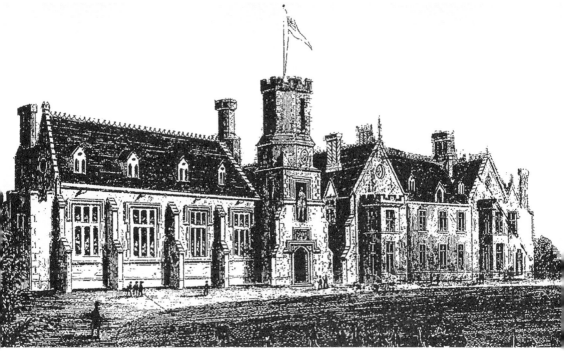

Above: Swansea Grammar School in 1853. (Reproduced from David Taylor's collection with the kind permission)

Below: Swansea Grammar School in May 2018.

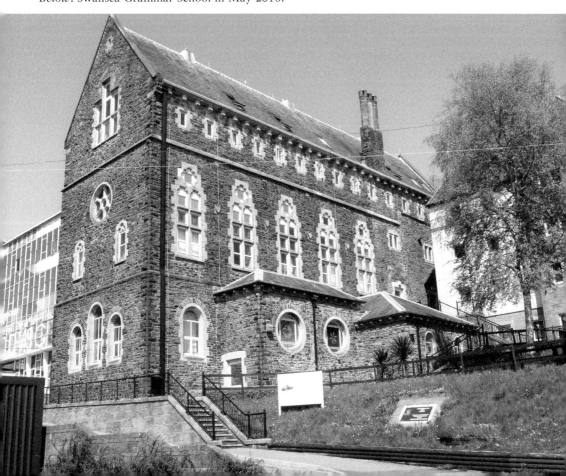

Of course, the original founder's name still lives on. After the bomb damage the school spent some years in alternative accommodation, before moving to its current site in Sketty in 1952 where it has evolved into Bishop Gore Comprehensive School.

20. Langland Bay Hotel, 1856

This is another of those grand residences that were built by rich industrialists. Few others enjoy a setting such as this 'charmingly situated and in every way pleasing', as the *Cambrian* newspaper said – although its history is less tranquil.

In the middle of the eighteenth century the land in Langland backing on to Newton Cliffs was purchased for £380 by George Phillips of Gower, who opened a quarry. It was inherited by his grandson John Hughes, who built two villas, which he rented out to those eager to enjoy the sheltered location and the warm microclimate. One of the earliest guests was Henry Crawshay, one of the extremely wealthy Merthyr Tydfil Ironmasters, a man used to getting his own way. He was so enchanted by the site that he took a long lease on the two villas, and then took out a further lease to build a summer residence, thus effectively taking control of most of the estate.

It was built in a Scottish Baronial style, with turrets and towers, making it look like a medieval castle or a French chateau, rather ornate and out of place. They called it Llan y Llan, though nobody is quite sure why.

Undated postcard of Langland Bay. (Reproduced from David Taylor's collection with kind permission)

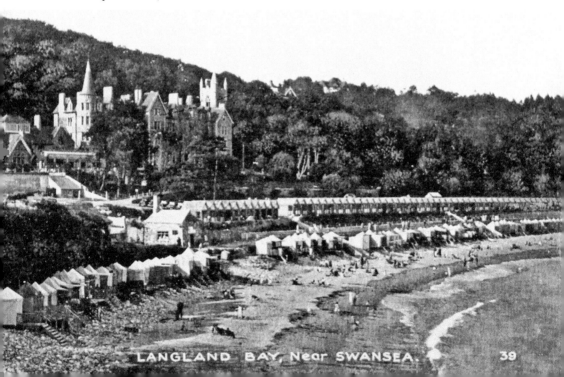

LANGLAND BAY, Near SWANSEA.

After the death of the Crawshays, the house was acquired in 1887 and converted into a luxury hotel by a syndicate of local business men. 'The sanitary arrangements are perfect, and the pure ozone of the Atlantic is wafted without obstruction direct to the rooms.' It was extended and a third storey was added.

The hotel was sold on to the New Langland Bay Hotel Company, but financial success was elusive and in 1900 a receiver was appointed. There followed a cycle of neglect and rebirth. It became a convalescent home for the Workingmen's Club and Institute Union and during the Second World War it served as a hospital. Now it has been renamed Langland Bay Manor and has been converted into luxury apartments.

The striking building in its beautiful setting is still pointing spikily into the sky behind the iconic Langland beach huts. You hope that it has found finally a sustainable future.

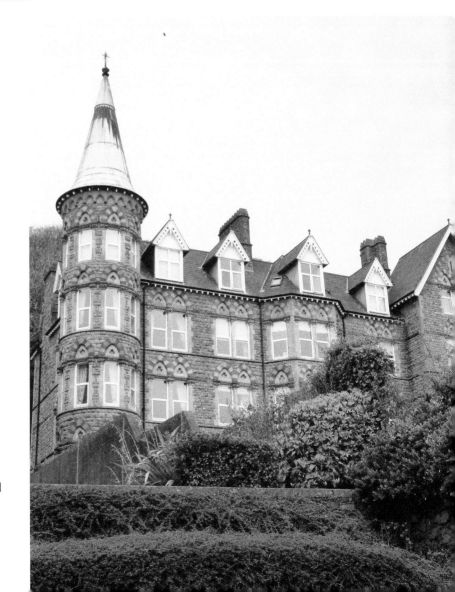

Part of the old Langland Bay Hotel.

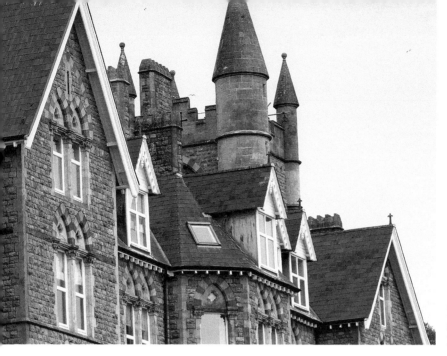

More detail from Langland Bay Manor.

21. Danygraig Cemetery Office, 1856

Danygraig Cemetery opened for burials late in 1856. You can find it on Danygraig Road in Port Tennant on the east side of Swansea, on the lower slopes of Kilvey Hill. It is a 20-acre site containing over 20,000 burials, and as you enter the grounds you will see in front of you the neat Victorian building that accommodates the cemetery office, square and approachable. The original two chapels that stood on the site have unfortunately been demolished.

This was the first municipal cemetery in Swansea, replacing the provision in the centre of town, which was becoming crowded and worryingly unhealthy, since the unreliable water supply in some streets could easily become tainted. In fact there were drainage issues in Danygraig itself, because it was built on old coal workings, which filled with water and needed to be drained. In 1872 the cemetery was described as 'one of the most miserable which could be found in the kingdom'.

Nevertheless, it was a popular place for peaceful afternoon strolls along the long paths, admiring the views across the new docks and out to sea and looking at the memorials to the local departed, both notable and otherwise, and was rarely out of the news. Families often complained about graves disturbed by workmen digging in the wrong place, leading them to believe that someone else had been buried with their loved one. It did happen. In 1908 there was an exhumation and a reburial as a result of such inefficiency – what the local paper described as a 'burial bungle'. In 1902 two funeral processions left Greenhill at the same time to find themselves squabbling for possession of the same grave. Earlier in June 1895 the decomposed body of a vagrant had been found attached to a tree in a shrubbery next to a family grave. 'A Suicide amongst the Dead' proclaimed the press.

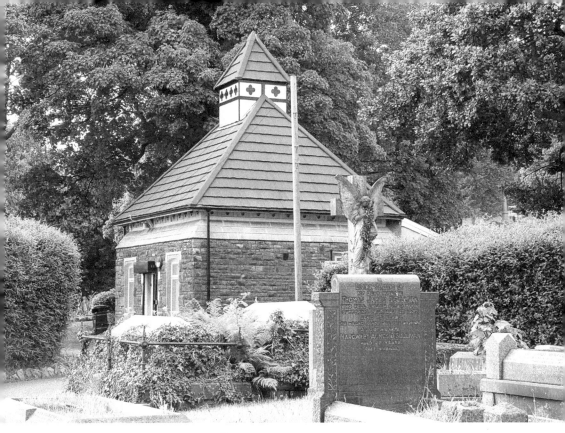

Above: The Danygraig Cemetery Office.

Below: The Cross of Sacrifice, Danygraig Cemetery.

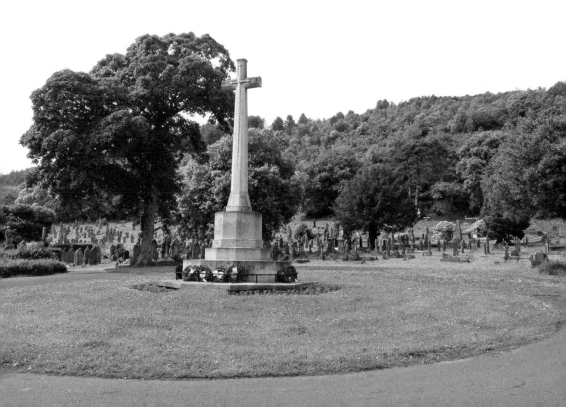

One hundred and twenty-seven casualties from the First and Second World Wars are buried here, including two Canadians and two Norwegian sailors. Consequently it has a Cross of Sacrifice, given to all cemeteries with more than forty war graves. The bronze sword that once decorating the front of the cross has disappeared.

22. Swansea Union Workhouse, 1862

Parishes were obliged to provide direct support to the poor, largely in the form of 'out-relief', which dated back to Tudor times. It was a tax collected locally to provide money, food and clothes and caused huge resentment, for it was believed to finance the lazy and the work-shy, reflecting the dangerous Victorian concept of the undeserving poor, as if people become homeless and destitute as a lifestyle choice.

The Poor Law Amendment Act of 1834 created Union Workhouses, where adjoining parishes came together to provide 'indoor relief' in a centralised workhouse, where a harsh regime would ensure that no one would ever wish to linger. Of course, many of those who found themselves there often did not have the means to escape, so it would never be merely temporary accommodation. The workhouse also provided otherwise unobtainable medical care, which represented an incentive to stay.

Poor relief had originally been provided in different locations in Swansea, originaly in part of the castle and then in the Bathing House on Mumbles Road,

Swansea Union Workhouse.

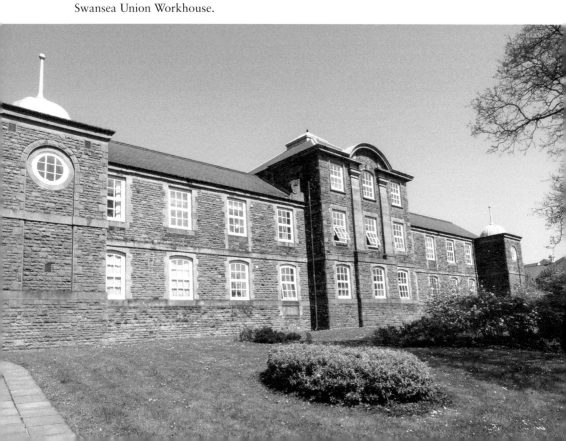

which, although inadequate, remained in use until 1864. The Swansea Union Workhouse was built in 1862 in Mount Pleasant at a cost of £15,780.

By 1895 it held over 500 residents, providing a exciting soap opera for the press, their tragedies forming a vicariously thrilling catalogue of misery. Mary Meagan fell into the North Dock and drowned while collecting firewood. Josiah Thomas collapsed and died in the street. Orpah Dennis arrived at the workhouse in 1897 with her dead baby in her arms. Harriet Thomas delivered a son in the workhouse, who lived for ten hours. In 1893 William Thomas hanged himself there. In 1900, George Williams was found dead on the beach, drowned, with a rag stuffed into his mouth.

It eventually became known as Tawe Lodge, as if a gentler name could somehow mitigate the shame it represented. The building became Mount Pleasant Hospital with maternity and geriatric departments. After it closed in 1995 it provided student accommodation until 2000. Today parts have been converted for residential use.

You can find the workhouse on Terrace Road, sternly elegant in its grimness, a forbidding permanence in its solidity, for the poor have always been with us.

At the rear of the workhouse.

23. St Andrew's Church, 1864 (Swansea Mosque and Islamic Community Centre)

St Andrew's Church is a prominent building with two tall towers, which start off as squares and then turn into octagons, high above the roofs of the city centre. It opened in 1864 on the corner of George Street and St Helen's Road and has an unexpected history. There is a clue in the name – St Andrew's – which reveals its Scottish origins.

It was paid for by Scots working in the drapery trade in Swansea and built in a style similar to churches in Glasgow. It was Swansea's only Presbyterian church and regarded – at least by its congregation in 1898 – as 'the most magnificent church in town'. Sadly over the years it fell into some neglect.

However, it has been offered a second chance. In order to cater for the needs of Swansea's growing Muslim community, a project is underway to redevelop it as a mosque on the other side of the road from the existing provision. A Muslim charity (Kafel Fund UK) bought the building from a private owner in 1997. They say, 'It is one of the most beautiful ecclesiastical buildings in Swansea and we are working to restore it.' It is a piece of Swansea's heritage that is in safe hands.

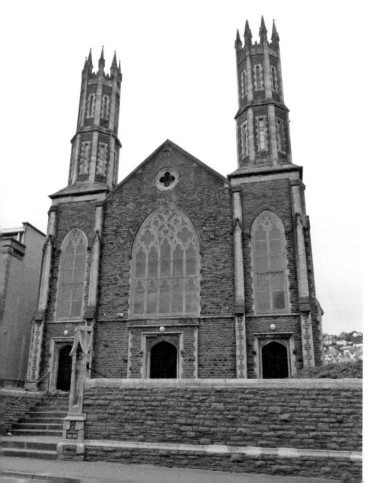

Swansea Mosque and Islamic Community Centre.

24. The Albert Hall, 1864

When the Albert Hall was opened in Cradock Street in 1864, it wasn't called the Albert Hall at all. It was the Music Hall and was built by the Swansea Public Hall Co. Ltd at a cost of £4,650. It had a spacious orchestra pit with a mighty organ and could seat 2,600 people, making it the largest public hall in the town, although it wasn't considered entirely respectable.

It remodelled itself during the 1870s as a venue for classical concerts, choral events, religious meetings and musical evenings. In 1881 it was refurbished and given a new name – the Albert Hall – in an attempt to confer dignity and respectability. It became the main venue for public events in the town. Adelina Patti performed an annual benefit concert there in aid of the local hospital. In 1901 a memorial was staged celebrating the reign of Queen Victoria; a concert was held there after the sinking of the Titanic in 1912. It was also used as a place of worship on a Sunday and it was always available for wedding receptions too.

The Albert Hall began showing films in 1914 and in 1922 it was remodelled as a cinema, with audio equipment added in the late twenties. It was Swansea's grandest cinema until its closure in 1977, when it evolved into the Top Rank Club, famous for its bingo.

The distressed condition of the Albert Hall in 2018.

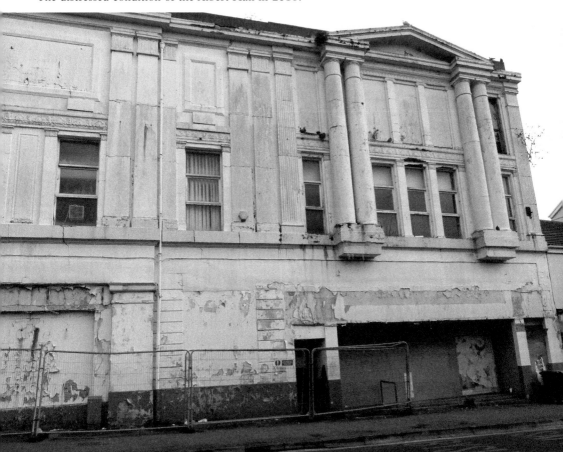

It is interesting how these different incarnations of the Albert Hall have always reflected the changing tastes in popular entertainment – and there could be further changes in the future. An air of neglect might hang over the building but there are plans for yet another rebirth, with the conversion of the upper floors into student accommodation and a retail outlet proposed for the ground floor.

I am convinced those students will regret missing Charles Dickens's visit in 1867 when he read from his work to a large and excited audience. They will be similarly disappointed that they could not enjoy Oscar Wilde's lecture on the 'The House Beautiful' in 1884, during which he thrillingly denounced antimacassars and white marble mantelpieces.

Me? I am sorry I missed the performance in February 1899 of Mr Harry Bartlett's Ladies' Mandolin and Banjo Orchestra.

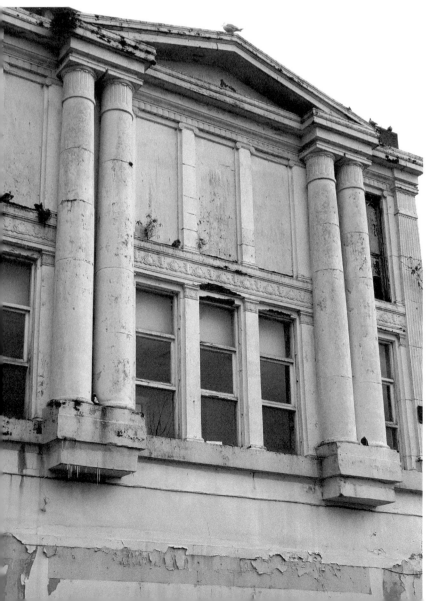

Detail from the Albert Hall.

25. The Adelphi Hotel, 1865

The Adelphi Hotel on Wind Street, with a distinctive stepped gable, which seems to have been transported from Holland, is one of Swansea's most famous public houses.

Mr Ingram was first granted a licence for a public house in 1865 and ten months later he was fined for keeping a disorderly house. Things did not improve. In 1867 a seaman, Carl Baralzel, was stabbed by Morgan Vaughan outside and Ingram was summoned for having a defective grating. He was pursued for non-payment of rates, a failure to pay wages to James Mahare and, oddly, for falsely imprisoning Hayward the plasterer. Ingram accused the police of having a grudge against him and the Adelphi was taken over in 1871 by a new proprietor from Cardiff, Mr Atkins.

He ran a busy advertising campaign in 1871. The Adelphi had been 'entirely refurbished' with 'bedrooms with all that can be desired. Charging moderate. Chops and steaks on the shortest notice.' As if to underline his promise, a few weeks later he advertised for a 'good plain cook'. Much of Wind Street remains desperate for a similar appointment today.

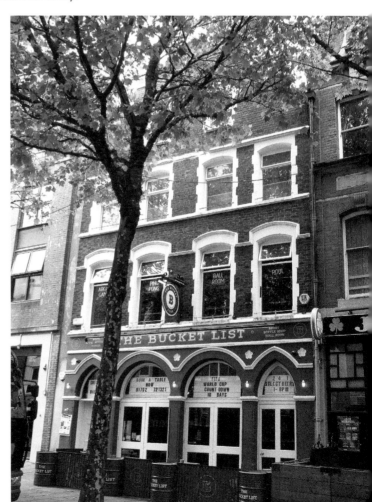

Originally the Adelphi Hotel on Wind Street.

The history of the Adelphi continued to embrace assaults, disorderly conduct, bankruptcies, thefts, billiards and heart attacks. In 1883 it was granted a music licence, preparing for its future popularity as a karaoke venue.

It has had a wide range of names including, inexplicably, the Rat and Carrot. At present it is The Bucket List but in Swansea's history it will always be the Adelphi, with a particular place in local mythology. There are those still convinced that in 1944 Rocco Marciano was arrested here after assaulting an Australian serviceman who had taunted him for drinking milk. Marciano was encouraged to take up boxing to channel his aggression and became undefeated world heavyweight boxing champion. There are just as many who dismiss the story as a fantasy.

In July 1918, and much more poignantly, the press reported the death of the landlord of the Adelphi, David Evans, who worked to help transport those caught up in the Spanish Influenza pandemic to Swansea General Hospital. He caught the virus himself and died.

26. Mynyddbach Chapel, 1867

You will find Mynyddbach Chapel set back from Llangyfelach Road in Treboeth, next to the Welcome Inn. It is the oldest Independent chapel in Swansea. It was built in the nineteenth century, renovated in the middle of the twentieth century and threatened with demolition in the twenty-first. However, it was saved by a group of local activists and we should thank them, not only for the preservation of a lovely chapel, but also for saving one of the graves in its cemetery, one of the most important in the Swansea – that of the poet Daniel James who wrote the words of the hymn 'Calon Lân', regarded as the second national anthem of Wales.

In Daniel James' life (1848–1920) you can see some of the regular tragedies of working-class existence in the nineteenth century. He was born in Treboeth and worked in the Morriston Ironworks from the age of thirteen following the death of his father, before moving to the tinplate works in Landore. Daniel was a regular customer of The King's Head on Llangyfelach Road where he would sometimes write verses in return for beer. Inside the chapel you can see the tall spindly chair upon which he sat at the bar while bartering his words.

When his wife died he was suddenly a widower with five young children. He soon remarried to Gwenllian Parry, herself a widow with five children of her own. They went on to have three more children together.

When the tinplate works closed in 1894, they moved to Blaengarw, north of Bridgend, where he worked as a miner, though sadly Gwenllian died a year later. It was here that he composed 'Calon Lân'. He later worked as a gravedigger before returning to Treboeth to live with his daughter Olwen. He died in 1920 and shares his grave with his first wife Ann and their son William, who died in a mining accident.

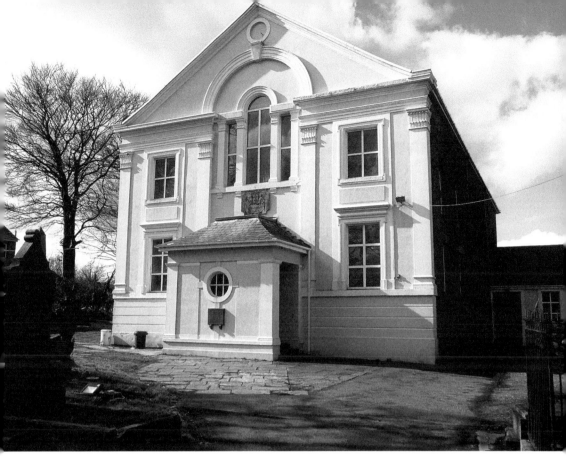

Above: Mynyddbach
Chapel.

Right: The grave of
Daniel James.

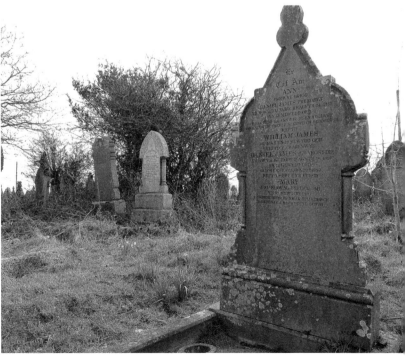

'Calon Lân' features regularly at weddings and funerals and it speaks of how a pure heart full of goodness is more important than riches. It is also sung with enthusiasm before rugby internationals too, perhaps because of the power of the music composed by John Hughes, rather than an unshakable belief in lyrics that tell of how none but a pure heart can sing.

27. Morriston Tabernacle, 1872

With very good reason, Morriston Tabernacle on Woodfield Street has been called 'The Cathedral of Non-Conformity.' It is a magnificent building with stunning visual impact.

The architect John Humphrey, known as 'God's architect', the builder Daniel Edwards and the minister Emlyn Jones toured the country visiting chapels and distilled what they saw into the ultimate expression of the Welsh chapel. It was completed in 1872 at a cost of over £18, 000, a huge sum at the time.

Below left: Undated postcard of Morriston Tabernacle.

Below right: Morriston Tabernacle, 2018.

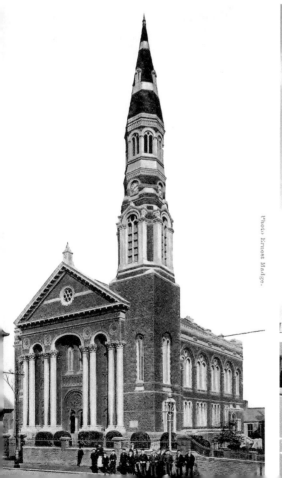 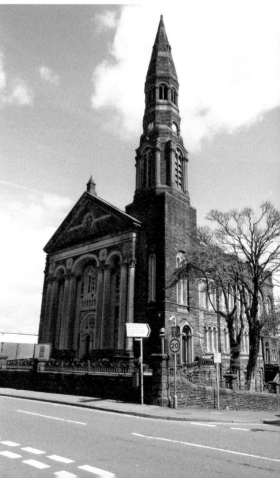

It was designed to accommodate the fall in the ground as it drops down towards the river. There are eight impressive Corinthian columns and arches which welcome the congregation, called to worship by that huge 160 feet spire.

The interior is similarly magnificent, with beautiful carpentry in mahogany and a swooping choir gallery.

Tabernacle was built in response to the rapidly growing population working in the industries that enveloped Morriston. It was described as 'the one great redeeming feature in that manufacturing district, an oasis in a desert'. In 1910 membership had peaked at 1,059.

By January 1914 all loans had been paid back and the chapel was finally free of debt after forty-two years. There was a celebratory concert led by Revd Emlyn Jones, who had been there from the start. Daniel Edwards was present, although John Humphreys had died. There was a tea for members of the church and the Sunday school had over a thousand guests. One of the speakers, Revd Morgan, said it was good 'to have killed the Amalakites and to be able to enter joyfully into the land of Canaan'. Morriston has never been a place for understatement.

The building has had its troubles of course. Inevitably it has suffered from levels of water penetration, but it is a much-loved building and a £1.5 million

Interior of Morriston Tabernacle.

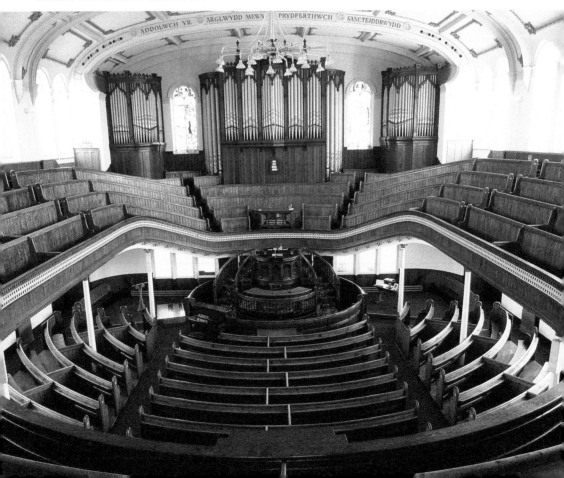

programme of restoration keeps this Grade I-listed building alive. It still holds services and concerts, still houses a fine and restored forty-stop organ, and is still admired and enjoyed. It isn't a surprise that in 2017 it was voted as Wales' favourite place of worship in the 'Cymru Sanctaidd' (Sacred Wales) competition.

28. The Annealing Building, 1874

On the eastern side of the River Tawe, across the Beaufort footbridge in Plasmarl, you will find the last remaining fragment of Swansea's tinplate industry. The sadly ruined building was once the Annealing building of the Beaufort Tinplate Works.

The site was originally the home of the Lower Forest Copper Mills, which was converted to tin plate production in the early part of the nineteenth century. The industry developed quickly to fill the gap left by the decline of the copper works to the extent that Morriston became known as the 'Tinman's Suburb'.

The rolling mill would originally have been water driven, using water extracted from the river, until it was replaced by steam power. The building, which still remains, although now trapped within untamed undergrowth, was once at the end of the rolling mill and was where annealing happened, the process in which metal was heated and then cooled to make it more workable. The date of the copper slag keystone indicates that it was built in 1874. It is a proud rectangular stone building with now-bricked-up arched windows. It still seems solid enough but is sadly derelict inside. It was once restored but was badly damaged in a fire. It is a sadly neglected relic of our industrial past.

The Annealing Building.

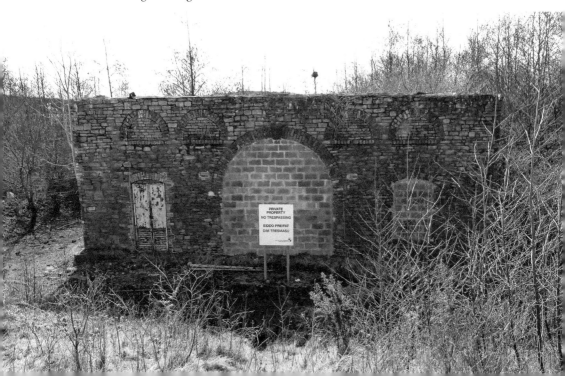

29. The Ice House, 188o

In the nineteenth century ice was a 'valuable and inexpensive luxury' and all your domestic needs could be fulfilled by block ice imported from Norway, available from the Swansea Ice Company in St Helens. Business demand was increasing too and so The Ice House was constructed on the fish wharf on the east side of the River Tawe, perhaps in 1880, in order to supply ice for the thriving fishing boats and for the fish market close by.

The building is of solid-looking red brick and what catches the eye is the chimney of the engine house, where a coal-powered steam engine drove the ammonia compressors that created the ice.

The building became redundant when it was replaced by a facility on the South Dock, which serviced the deep-sea trawlers. It was taken over first by a ship's chandlers and then later by flag-makers Mott and Jones, when it was known as the Flag Ship Building.

It was eventually restored to house six apartments and two restaurants. The area outside is known as Ice House Square and at night there is a dynamic lighting installation with sensors reacting to movement and creating grid lines of light on the ground. The Ice House is cool once more.

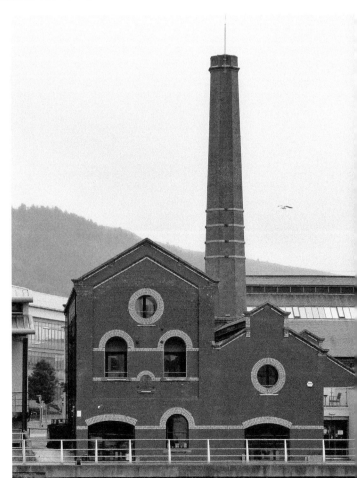

The Ice House.

30. The Old Central Library, 1887

The old Central Library on Alexandra Road is an excellent example of Victorian design and was an integral part of civic life. The impressive circular reading room, 26 metres in diameter and full of classical detailing, was designed to encourage learning and reflection. There is still an imposing cupola in the roof, which was once damaged in the war, but is now restored.

It was opened in June 1887 by William Gladstone, the ex-prime minister, when he came to Swansea to stay with the Vivians at Singleton Abbey. He was given a golden key, presented in a velvet case by William Williams, jewellers of Castle Street. He also received a piece of polished coal from Clydach and a steel woodman's axe, an appropriate gift for a keen tree feller. Gladstone then gave a speech, which 'occupied twenty-six minutes in delivery and dealt mainly with the value of such institutions'.

It wasn't always treated with respect, however. In 1894 the Library Committee were especially agitated by someone deliberately mutilating the newspapers. A piece had been cut out of the *Western Mail* advertising a vacancy for a gardener in Pembrokeshire. They asked the advertiser for help in 'detecting this delinquent' by examining applications. Generally, though, it was always a much-loved public lending and reference library. It relocated to the Civic Centre in November 2007 and the building is now the ALEX Design Exchange at Swansea College of Art, part of the University of Wales Trinity Saint David.

The old library was built for £16,000. The refurbishment cost over £9 million. The beauty of the building has been conserved and it now lives on in a modern context as a centre for research and design, augmented by a neighbour of distinctive angular glass.

Undated postcard with the Central Library in the foreground.

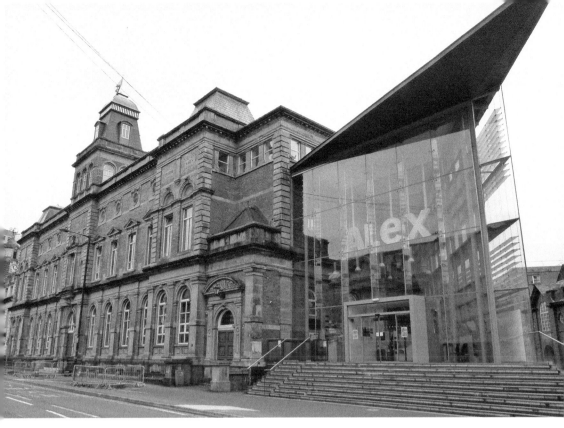

Above: Changing Times. The Old Central Library in June 2018.

Right: The circular Reading Room and cupola.

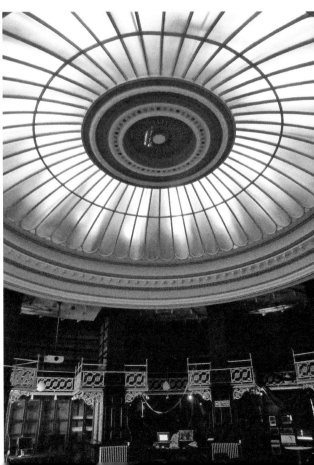

The library was central to the plot of the 1962 Peter Sellers film *Only Two Can Play*, which was filmed around Swansea. However, the Glynn Vivian Art Gallery, on the opposite side of Alexandra Road, acted as the library because it seemed to have a more imposing entrance. I am pleased to report, though, that the library achieved fame in its own right when it was used in *Doctor Who* episodes 'Silence in the Library' and 'Forest of the Dead'.

31. John S. Brown's Ironmongery, 1893

This is No. 21 Oxford Street, close to the junction with Plymouth Street, one of the gems of Swansea. Up on the roof and rarely noticed by busy people below, two lions once announced the opening of a new shop – John S. Brown's Ironmongery. It was regarded as 'one of the finest edifices in the town … of red brick, with white stone facings'. Sadly, we have lost 'the highly architectural cupola with a clock' that stood in the middle. The business had been established in 1879 at No. 62 Oxford Street and by 1893 he moved his shop into much grander premises across the road.

The old John S. Brown's Ironmongery, Oxford Street.

Brown sold a huge array of goods in what he proclaimed 'the largest show rooms in Wales', which spread over two floors. There were large items like cooking ranges, mantelpieces, tiled stoves and sanitary fittings. It was certainly the best place in Swansea to buy a bicycle. Brown claimed to have the largest selection of tools 'ever seen in Wales – Inspection respectfully solicited', as well as razors that were all tested by a 'working Sheffield cutler … constantly employed on the premises'. Other staff included 'electric wiremen'.

John Brown was at the forefront of the development of electrical services in Swansea. He became the main electrical contractor for the Swansea Harbour Trust, the Grand Theatre and Craig y Nos Castle. His brightly lit window displays were much admired and in 1896 he was awarded third prize in a window-dressing competition sponsored by the *Ironmonger's Chronicle*. Heady days indeed.

To draw attention to his store he installed a powerful searchlight on the roof, exciting the people of Mumbles and allegedly causing insomnia in Sketty. He used it to broadcast election results, publishing a code to distinguish between the candidates – a revolving light in the 1910 general election indicated the success of Alfred Mond, the Liberal candidate.

JOHN S. BROWN

FOR

RAZORS

THAT WILL SHAVE.

All carefully Tested by an Experienced Working Sheffield Cutler, who is Constantly Employed on the Premises.
RAZORS CAREFULLY GROUND AND SET.
EVERY DESCRIPTION of TABLE and POCKET CUTLERY, SCISSORS, &c., EFFICIENTLY GROUND and SET at Lowest Charges.

JOHN S. BROWN,

MANUFACTURING CUTLER,

OXFORD STREET, SWANSEA

Above: Razors at Brown's (an advertisement from 1899).

Right: Bicycle advertisement, 1906.

JOHN S. BROWN
FOR
SINGERS

JOHN S. BROWN
FOR
TANDEMS

JOHN S. BROWN
FOR
GIRLS' AND BOYS' CYCLES.

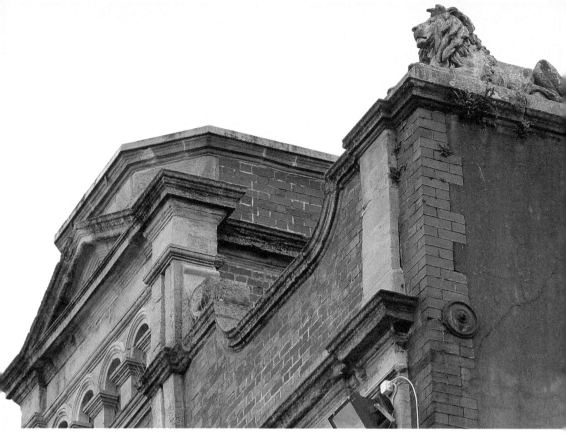

One of Brown's lions in 2018.

The shop closed in 1929 and the building was taken over by Macowards. It remains distinctive among the unimaginative drabness that surrounds it. That beautifully shaped first-floor window still draws the eye, with so much more grace than the ground floor deserves. The lions are still there, their paws still resting upon a ball, but now defying the sprouting weeds that threaten them.

32. The Grand Theatre, 1897

The Grand Theatre was built on the site of the Drill Hall on Singleton Street in 1897 by two actor-managers Morell and Mouillot, who employed William Hope as their architect. It was designed in Renaissance style and the *South Wales Daily Post* enthusiastically reported that the materials used for the walls were 'white stone and red brick, faced with roughcast plaster. Dark red bricks are used at all angles, and terra-cotta has been freely used for the ornamental portions.'

The auditorium accommodated 2,500 people across the three tiers. 'There is probably no theatre in the Principality so replete with modern accessories for the adequate production of stage plays.' The first production to enjoy these facilities was *The Geisha*, a Japanese musical comedy, and the theatre welcomed many touring companies, which occasionally included notable performers such as Henry Irving and Ivor Novello.

OPENING OF THE GRAND THEATRE.

A BRILLIANT ASSEMBLY WITNESS THE INITIAL PERFORMANCE AT THE NEW OPERA HOUSE.

A Notable Audience— and a Meritorious Performance,

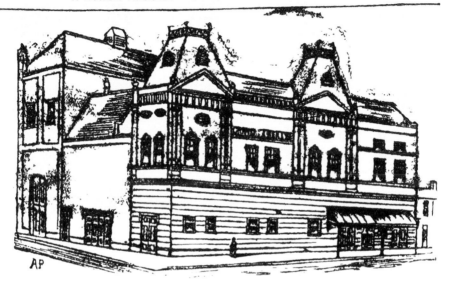

From the *Cambrian Daily Leader*, 1897.

In 1931 the theatre became a full-time repertory theatre, but audiences were not encouraging and returned to receiving touring shows until it became a cinema in 1933 for fourteen years, for in the face of film it was hard for live theatre to compete.

It reopened as a theatre in 1947, significantly with the pantomime *Babes in the Wood*, for the Grand Theatre has had a long-standing enthusiasm for the Christmas period, since the income has always sustained the rest of the year. It became a repertory theatre again in the fifties with a remarkable cast, which included Wilfrid Brambell, Richard Burton, Rachel Roberts and Kenneth Williams. However, the place was fragile and, although it survived a demolition threat, by 1959 it resorted to showing films again for four months, this time adult features.

The application to convert the theatre to a bingo hall in 1969 was thankfully rejected and eventually, after more closure threats, Swansea Council took ownership and funded extensive alterations and additions in the 1980s. The capacity was reduced but technological improvements ensured its continued popularity to touring companies and comedians.

The Grand Theatre, although altered, is William Hope's only surviving theatre and, should the Grand Theatre ever require a coat of arms, then it must surely include the words 'I Will Survive.'

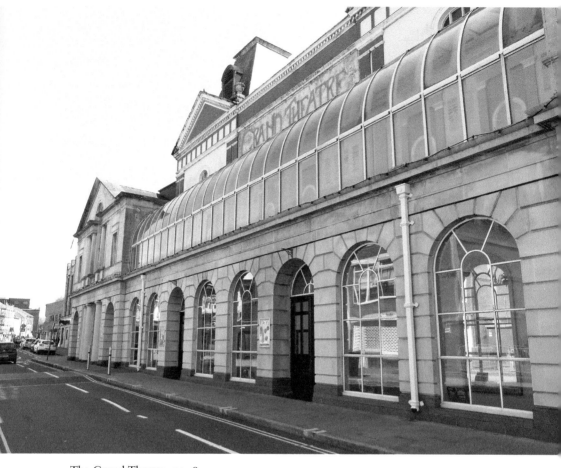

The Grand Theatre, 2018.

Waiting for your hugs and kisses and your money too.

33. Mumbles Pier Public Conveniences, 1898

These are top-quality toilets, and well-arranged too, with discreet entrances for girls on the left and boys on the right. You couldn't ask for more. It can be no surprise that this attractive and surprising structure is a Grade II-listed building. It might be an unexpected choice for this book but it is something we should regard with pride.

You will find them at the end of the sea front in Mumbles. They were built in 1898 at the same time as the pier and situated conveniently near the terminus of the Mumbles Railway.

Clearly they were built against the rock face, looking like a mini-castle or the gatehouse to a country estate, with those fine crenellations making it look attractive and imposing.

In the middle you have a two-storey central tower with an oculus, or a circular window, facing out to sea. The business parts of the building are on either side. Above there is a balcony, with railings to reassure the safety-conscious. The windows are a lovely feature. The steps to the side form part of the Wales Coastal Path.

These toilets were built with such pride. After all, there is no reason why something functional should not be designed and created with style and you may be sure that, at the end of their task, the builders went home, relieved that the job was done and flushed with success.

Mumbles Pier public conveniences – always a relief.

34. The Swansea Harbour Trust, 1903

The Swansea Harbour Trust was established in 1791 in order to expand the business of the port. The trust had offices on Wind Street and held their monthly meetings in the Guildhall, tirelessly nurturing the prosperity of the town. Eventually a new building was needed.

They acquired the site of the Harbour Hotel in Somerset Place and a design competition was held before the contract was awarded to Edwin Seward, a Cardiff architect, who created an elegant and imposing building, which opened in 1903 and 'practically remodelled the whole appearance of this part of Swansea'.

The most obvious feature is the attractive red brick, which is 'diversified with bands of Portland stone', but the tower is also striking, with a dome of copper, weathered to verdigris, beneath a vane representing a ship in full sail. It is also decorated with statues representing Commerce, Discovery, Shipbuilding and Engineering. These seated figures were modelled by a local woman Frances Gray and created by Marco Fabbeni, who had a workshop on St Mary's Street.

The building had two entrances. The public one on Adelaide Street led into the Shipping Office with its desks of polished teak and then a private entrance in

Swansea Harbour Trust.

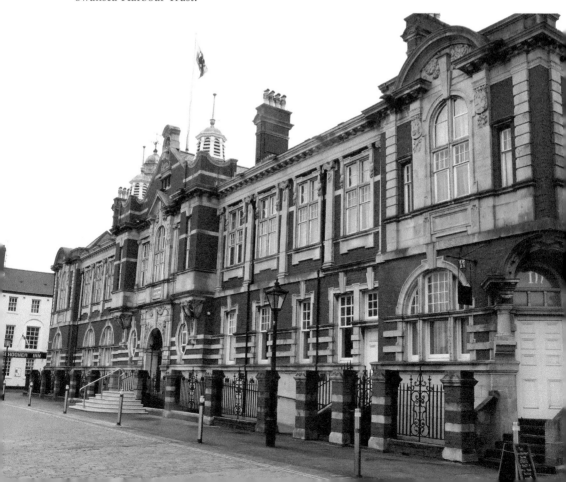

The tower with its dome of copper.

Somerset Place for the staff. At the rear on Pier Street there was an annexe, which was rented out to the Capital and Counties Bank.

The interior fittings were similarly notable and reflected Swansea's sense of economic confidence. People came to see the stained glass, the domed roof, 'the electric lights in handsome electroliers throughout'. They regarded the boardroom as the best in Wales, with a large solid 29-foot-long teak table surrounded by thirty crimson leather-covered oak chairs. The Chairman's Office was fitted in mahogany.

Swansea is a different place now. It is no longer a major port, exporting anthracite coal and importing grain, but the building has survived with a new identity as a luxurious boutique hotel that respects those impressive original features. Spared wartime damage, we still have the opportunity to enjoy this special building. When it is beautifully illuminated in the darkness, we can appreciate the pride our ancestors had in their town.

35. Municipal Telephone Exchange, 1903

In November 1903 Swansea's Municipal Telephone Exchange was opened by the lord mayor on Pier Street. He expressed considerable civic optimism in the development, for he was sure there was a big future for the telephone.

Telephone lines had started to appear in Swansea in 1880 and the town became an enthusiastic early adopter of the 'wonderful invention of audibly speaking

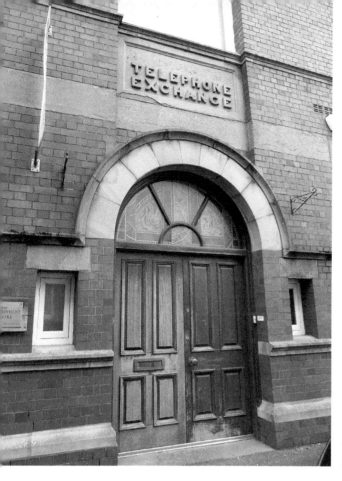

The Municipal Telephone Exchange.

through wires', stretching out from the telephone exchange in the Castle Buildings on Wind Street – a suitably high point from which the lines could radiate. The post office converted its telegraph service into telephone exchanges and it opened in October 1888, generally to serve businesses in the town centre, with users being manually connected by an operator.

Over the next few years more of the town became connected and there was a growth in domestic users, with personal instruction being offered to female users. The service offered by the Post Office was not reliable and the 1899 Telegraph Act allowed authorities to set up their own exchanges. Swansea applied for and was granted a licence. There was a hint of profit to be made and there were 'manifold defects' in the existing system to resolve.

Swansea's Municipal Exchange would offer the considerable benefit of preventing your conversation being overheard by others and it would have a ring-back service if the line you wanted was engaged. Of course the whole system was soon united into one national telephone system operated by the post office and the money Swansea invested in its own exchange was quietly written off.

The Telephone Exchange is now the Swansea Environment Centre, which adapted the building and reused materials while preserving its history. The pleasing annex was constructed in 1999 and has a sympathetic design built with respect

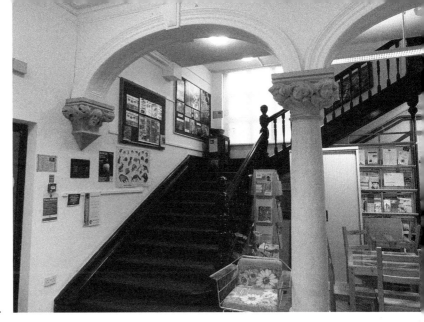

The staircase, now serving the Swansea Environment Centre.

for ecological principles. Water is heated by the solar panels, which also provide underfloor heating. There is a turf roof and an organic garden. The centre has run activities like an 'Eastside Fridge Swap' to replace old domestic appliances with more efficient ones. The Environment Centre also offers space to other important organisations, putting it at the heart of sustainable Swansea.

36. The Glynn Vivian Art Gallery, 1909

I have chosen 1909 for the Glynn Vivian Art Gallery to honour the benefactor Richard Glynn Vivian (1835–1910), for that was when he laid its foundation stone. He died before it was finally opened in 1911. It was pronounced 'a princely gift for Swansea of which the town will be proud and one which will hand the name of the generous donor down to future generations'. It has certainly done this.

The Vivian family, for better and for worse, have left their mark upon Swansea. Originally from Cornwall, they developed the copper industry in Hafod, amassing considerable wealth. Richard Glynn Vivian, however, had little interest in the family business, leaving such things to his brothers. He was more interested in travel and art, living in London and Europe, eventually returning to Swansea in 1898 at the age of sixty to live in Sketty Hall. He supported philanthropic projects including a Home of Rest for the Blind in Mumbles and a number of miners' missions.

In March 1902 he began to lose his sight, becoming almost completely blind, and in 1905 he offered to Swansea his 'valuable and unique collection of art objects' and a new £10,000 gallery in which to house them. The Corporation initially hesitated, unwilling to agree to maintain the gallery. Negotiations were protracted to the extent that the frustrated Glynn Vivian withdrew his offer. It was only after a poll of ratepayers gave their approval that building began. We should thank them for their vision and good sense. He also endowed it with £1000 for the

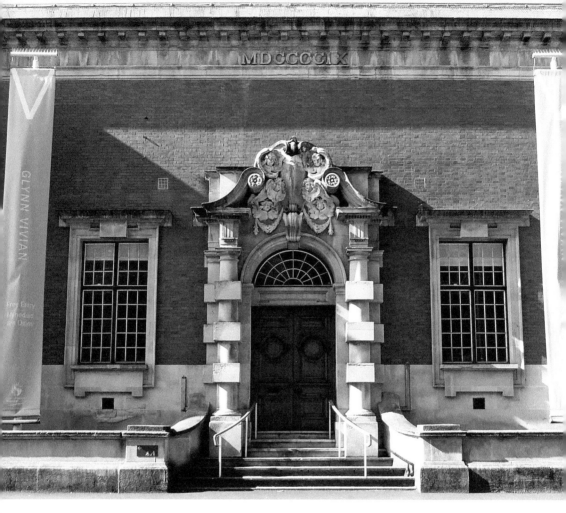

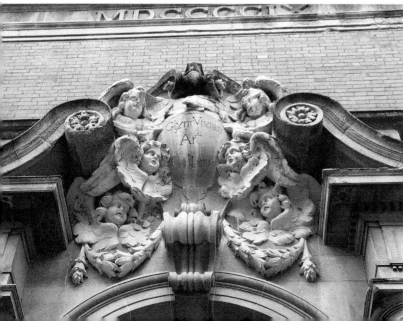

Above: The entrance to the Glynn Vivian Art Gallery.

Left: Above the entrance.

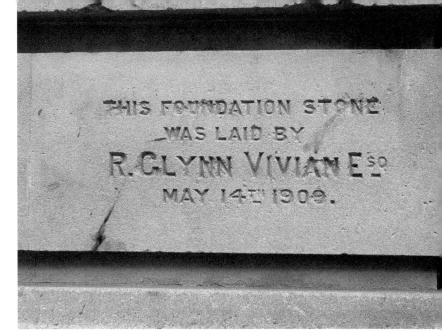

The Foundation
Stone facing
Alexandra Road.

purpose of instructing poor ladies in the copying of miniatures and artworks
for a livelihood – an enterprise which sadly has not prospered. In May 1909
he laid the foundation stone, his hands 'guided by attendants to use the trowel
and mallet'.

The collection houses significant works by Richard Wilson, Monet, Doré
and the wonderful *Orléans Cathedral* by Turner. There are important canvases
by local artists like Evan Walters and Ceri Richards and an extensive display of
Swansea pottery.

The gallery was closed for considerable redevelopment and reopened, preserved
and transformed in 2016.

37. Sjómanns Kirken, 1910

The Strand was always Swansea's very own 'Garden of (Earthy) Delights'. Down
there next to the docks all a sailor's needs could be resolved. However, at the
bottom of The Strand there was also a place that catered for the spiritual needs of
a lonely sailor – as long as he was Norwegian.

At the junction with Quay Parade there is an imposing building that appears
to have been built during the eighteenth century and eventually became known
as the Colonial Buildings. It is solid and rectangular, familiar and strong, and has
had a number of identities – including as domestic premises and as a warehouse –
but it has always had a large sail loft, where once Scandinavian sailors gathered
together to worship. The space was always open as a place for religious devotion
and as a social club. Sailors would be able to 'worship in their native tongue and
also be prevented from falling into the way of temptation' – always a tricky task
on The Strand.

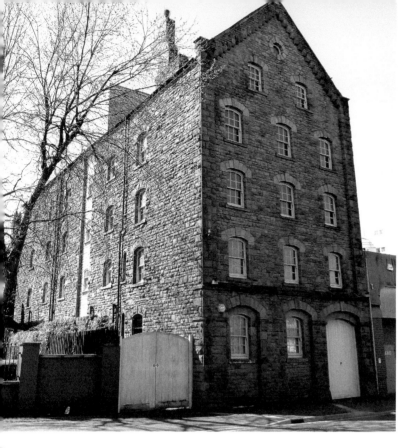

Left: The Colonial Building, first home of the Norwegian congregation.

Below: The Norwegian Church on the Prince of Wales Dock.

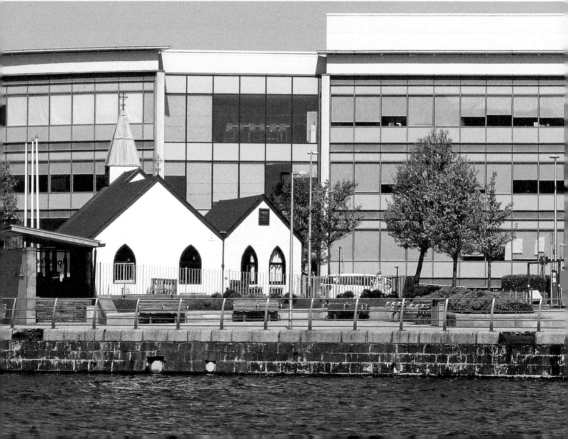

During the late nineteenth century the mission, in which the local chandler Lars Knutsen was a leading figure, was led by Pastor Sivertsen. They were key figures in the relocation of this congregation.

In 1909 the pretty corrugated-iron Norwegian Church, which had first been erected in Newport Docks, was moved to Swansea. There had always been well-established links between Swansea and Norway, based upon the import of timber for pit props with the ships then filling up with coal as their return cargo. In 1910 at the opening of a Norwegian Bazaar held to settle the debt for the relocation of the building, it was said that 10,000 Scandinavian seamen entered the port during the previous year.

Initially the church was located at the main entrance to Swansea Docks where it remained in use as a mission until 1998.

In 2004 the building was dismantled once again and moved to its present location beside the Prince of Wales Dock at the junction of Langdon Road and Kings Road, where it is currently offers nursey care provision. However, the attractive Sjømanns Kirken, which for generations of Swansea people has represented the docks and the international connections that underpinned the town's development, is still open and still in use.

38. The Ragged School, 1911

The Ragged School movement began in London in 1844 and the Swansea School was founded in rooms in Back Street in 1847 by Dr William Michael, the town's first medical officer. The name reflected the concern that the most destitute children were often turned away from Sunday school due to their 'ragged' appearance. As the *Cambrian* newspaper observed, it would be welcomed in parts of Swansea where 'the people are prostrate in vice and misery ... a school where the ragged, the wretched and the most destitute may assemble and receive religious and moral instruction'. It survived entirely upon public subscription and charitable donations.

It thrived and by 1913 there was an average attendance of fifty in the morning, rising to 310 in the afternoon when many children finished work. It would eventually offer night-school classes to broaden its reach.

The school also ran a savings bank especially for mothers, 'second only to the Bank of England and equally safe'. In the harsh January of 1910 it acted as a soup kitchen, serving 150 children every Friday, 'many of them bare-headed and barefooted and some carrying little brothers and sisters'. The numbers of children reached were always impressive. When the school organised its annual summer outing to Langland it usually took over 650 children down to Mumbles on the train.

In 1911 the school moved a short distance to purpose-built premises on Pleasant Street, now behind the Orchard Street car park. That date can be seen clearly above the doorway and on the foundation stones, one of which was laid by Amy Dillwyn,

novelist, industrialist and one of the school's benefactors. It is a striking two-storey symmetrical brick-built building. Beyond that beautiful arched entrance, much of the interior remains intact, including the upper floor, which originally served as a chapel. It is said that behind a blocked doorway in the stairwell is a passage that once led to wartime bomb shelters beneath the old police station.

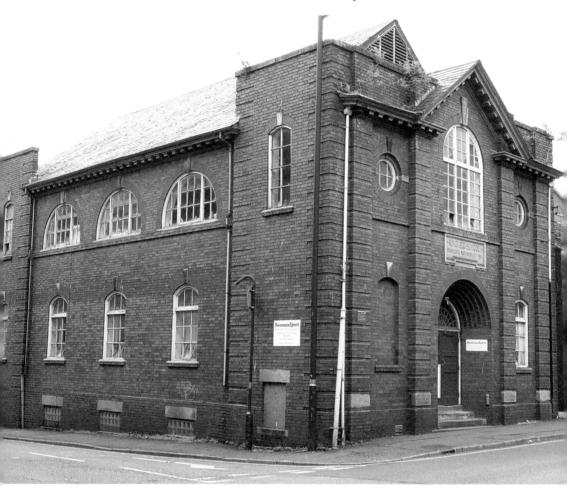

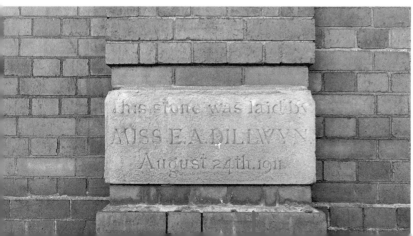

Above: The Ragged School.

Left: The stone laid by Amy Dillwyn.

It finally closed in 1956, although the name lives on in the name of a local amateur football team, and the building has found a new mission as the Centre for Greater Self-Awareness, providing courses and exhibition space.

39. The Old Central Police Station, 1912

The New Central Police Station, which was built in 1912, with later additions completed in 1915, is now the Old Central Police Station, but it still remains a splendid building. It was designed by the borough architect Ernest Morgan and built from Portland stone with contrasting brickwork, which makes it a striking building on a prominent site at the corner of Alexandra Road and Orchard Street. The first thing you notice is the concave front, which contains a convex porch and that landmark tower above, complete with clock and weather vane. The main entrance on Alexandra Road is flanked by a couple of fine Doric columns and next to it on the right you can see an architrave that marks where the entrance for the fire brigade used to be.

On the other side of the building there is my favourite feature, the excellent bartizan at the junction with Pleasant Street, which brings a touch of style and

Below left: The Old Central Police Station.

Below right: The bartizan.

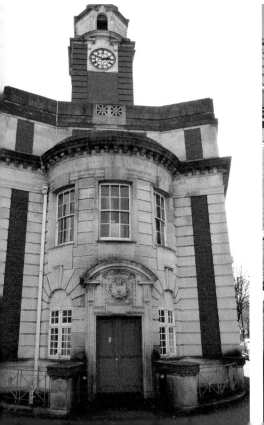

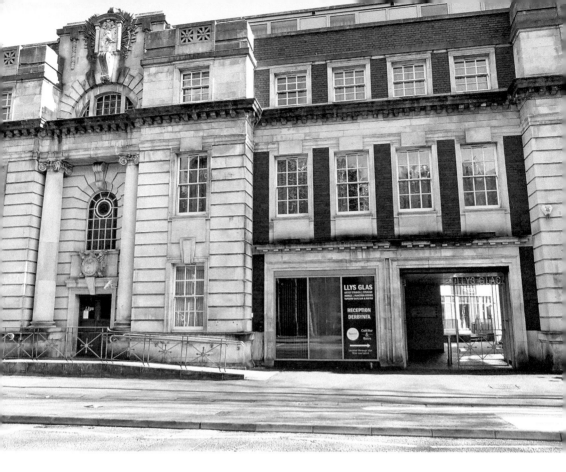

Where the fire engine emerged.

whimsy to what must once have been a forbidding destination. While many of our ancestors may have carried mental scars from a visit to the police station, the building itself has many physical scars of its own, for there is easily identified shrapnel damage from the Second World War, pox-marking the walls. However, the building survived that, just as it survived our neglect.

This Edwardian police station has now been preserved through its reinvention. As it got older and the police moved to the other side of the road, the building found itself in some distress. There was dry rot, crumbling windows and floors, and leaking roofs. Thankfully, in 2001 it was acquired by the Gwalia Housing Association, who carried out a sympathetic restoration so that the Central Police Station has become another example of how Swansea successfully uses its heritage in a creative way.

Now it is called Llys Glas, and it has a new purpose: it is the home of Swansea's Citizen's Advice Bureau. There are meeting rooms, student accommodation, artist's studios and a bistro called Tapestri operating as a social enterprise. There are now tables in the courtyard where there were once the stables for the horses that pulled the fire engines.

40. The Carlton Cinema, 1913

The fine Exchange Buildings on the corner of Adelaide Street and the Mond Buildings on Union Street were both designed by the Swansea architect Sir Charles Ruthen. His greatest achievement, however, was the Carlton Cinema on Oxford Street. It was built on the site of the Jeffrey's Arms Hotel by Henry Billings for the Swansea Electric Company in 1913. It cost £15,000 and *The Cambrian Daily Leader* excitedly reported that 'Every effort is being made, regardless of cost, to make this hall the most luxurious in Wales.'

Ruthin used reinforced concrete in its construction so that supporting columns for the circle, which would obstruct the view, would not be required. It could seat 600 on the ground floor and 300 in the circle. It also included, thrillingly, dimmable lighting.

It remains a perfectly symmetrical building. The two ornate end towers are still there, which once announced to the people of Swansea that a new cinema was waiting for them. Perhaps the most notable feature of the building is that delightful bay window, which must have shone like a beacon.

When The Carlton opened it 'was graced with a new chamber orchestra, consisting of piano, two violins, clarinet, cello, and bass violin' led by a new musical director Mr Adlington, 'a pianist and violinist of skill'. They would play every afternoon and evening. The opening programme in February 1914 included 'A Brother's Atonement', 'A Plucky Ranch Girl' and 'Sharp-Shooter Sam'.

Above left: The Carlton Cinema, now Waterstones bookshop.

Above right: Detail from the Carlton Cinema.

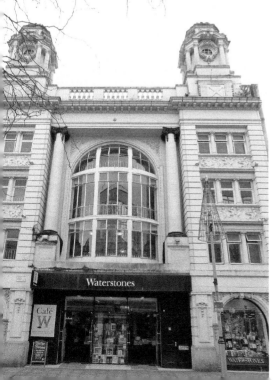
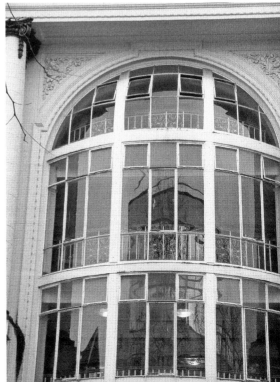

The Carlton, which also incorporated a restaurant, continued to be a magical place of dreams, providing a regular escape from everyday life for over half a century. It closed as a cinema in 1978 and seemed doomed to demolition, like the Empire Theatre, which had stood next door, but its survival was assured when it was granted status as a listed building.

Today the elegance of the Carlton Cinema is still there for all of us, in its sustainable status as a bookshop. The only part of the internal design that is still visible is the lovely swooping staircase you can see as you walk through the door, part of Swansea's architectural past that is still available for everyone to enjoy.

41. No. 5 Cwmdonkin Drive, 1914

There are two shrines to Dylan Thomas. One is his writing shed overlooking the estuary at Laugharne where you can peer through the window and imagine that the writer was there just a few moments earlier. The other is No. 5 Cwmdonkin

No. 5 Cwmdonkin Terrace. (Photograph reproduced with kind permission of the Dylan Thomas Birthplace)

Drive in the Uplands in Swansea where he was born in 1914. The house is a fascinating insight into his childhood and has been turned into an excellent visitor experience, regarded as one of the best small museums in the country.

His parents married in 1903 in the Congregational Chapel in Castle Street, which coincidentally became the Kardomah Café, later to become so important in their son's social life. They moved into their brand new, four-bedroom semi-detached house in Cwmdonkin Drive, which cost them £500 in 1914. In October of that year Dylan was born in the front bedroom. He lived here until he was twenty-three. His parents moved out in 1937.

Guided tours will show you the kitchen (and scullery) where the family ate together and the study in which his father would lock Dylan until he had completed his homework – after all, they spent their days together at Swansea Grammar School as pupil and English teacher. His bedroom, where he wrote most of his early work, may have been small, but his imagination ran free and expanded beyond the narrow bed and wardrobe and the gurgling pipes from the bathroom.

The house is on a steep hill opposite Cwmdonkin Park where young Dylan ran free with friends, where 'tigers jumped out of their eyes', and where he found the inspiration for much of his work. No one has written so well about childhood; no one else captures so vividly what it is like to be a little boy. In works like *Hunchback in the Park* his understanding and humanity rises above the debris of a turbulent life.

The house was restored over a period of three years and was eventually opened by his daughter Aeronwy in 2008. It was saved from sorry ruin and now known as the Dylan Thomas Birthplace, full of authentic Edwardian furniture and the unmistakable essence of Swansea's famous writer.

Dylan Thomas' bedroom. (Photograph reproduced with kind permission of the Dylan Thomas Birthplace)

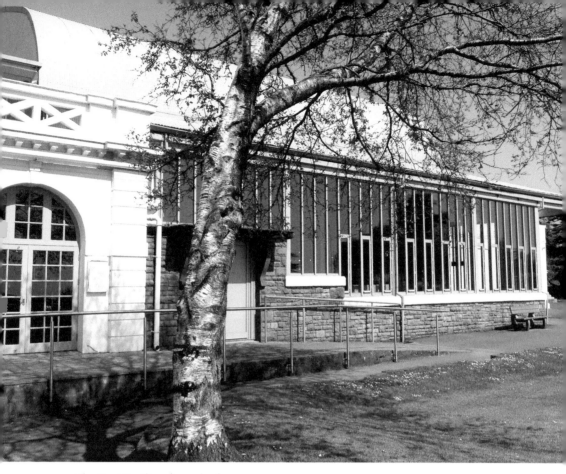

The Patti Pavilion from the front.

Adelina Patti, the foremost soprano of her generation and the first woman to be made a Freeman of the Borough of Swansea in 1912, was one of the town's most unexpected patrons.

Born to Italian parents in Madrid in 1843, she was an international superstar described by Guiseppe Verdi as the finest singer he had ever heard and became the highest paid singer of her generation, frequently requesting payment in gold. She had her own personal stalker who kissed the doormats on which she had trodden and a parrot that had allegedly been taught to swear in French and shout 'Cash! Cash!' whenever her agent appeared.

She bought property in the upper Swansea Valley in 1878 for £3,500, which allowed her second husband Ernesto Nicolini the opportunity to live the life of a country squire while she developed considerable skills as a billiards player. She spent a huge amount of money transforming it into a Gothic castle, which she named Craig y Nos, the Rock of the Night. The house, with its own private theatre, was the first private house in Wales to be wired for electricity and had an impressive Winter Garden, built in 1891, in which she could take sheltered walks among tropical plants and birds.

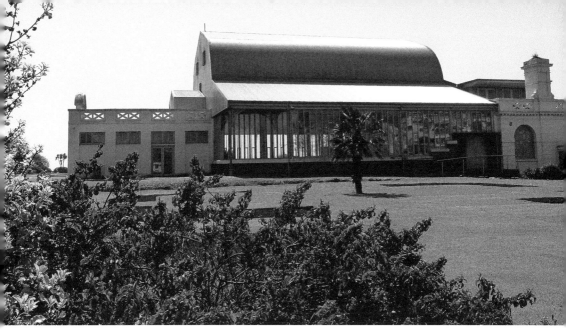

The rear of Patti Pavilion.

Adelina was always charitably inclined, offering her services at annual concerts at the Albert Hall in Swansea, and in 1918 she gave the Winter Garden as a gift to the town. Sadly there were not enough men available to move it during wartime and so it was not until 1920 that the Winter Gardens were dismantled and rebuilt at Victoria Park. The building was renamed the Patti Pavilion in her memory, for she died in 1919.

This landmark building, with its distinctive green roof facing Swansea Bay, has become a venue for performing arts with a function hall used for a variety of events including concerts and weddings. The pavilion has also been extended with the addition of an Indian restaurant.

Notwithstanding such culinary attractions, Adelina Patti still spends her time at Craig y Nos, enthusiastically haunting the castle, along with the composer Rossini for some reason.

43. Joe's Ice Cream Parlour, 1922

If anything represents Swansea then it is Joe's ice cream. Going for a Joe's? Everyone knows what that means. It is our badge of identity. It is certainly the case that a nostalgic yearning for Joe's is a means by which the Swansea diaspora identify themselves and, when they meet, they invariably and unconsciously repeat the company's ad-line: 'Everything else is just ice cream.'

It has been made in Swansea since 1898. The business was started by Luigi Cascarini from the Abruzzi region of southern Italy. He was working his way to America and arrived in Swansea on a coal steamer and never left.

He initially opened a food store in the High Street with borrowed money and worked extremely hard, to the extent that he was occasionally fined for illegally

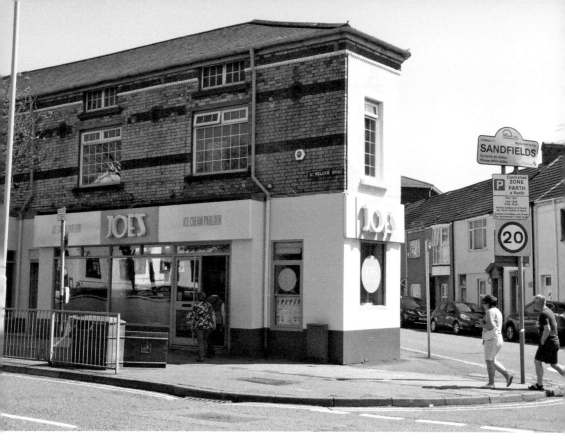

Above: Joe's Ice Cream Parlour, St Helen's Road.

Left: A Joe's sundae. (Photograph by Joe's, reproduced with kind permission)

trading on a Sunday. His six children joined him in his business and in 1922 his eldest son Joe took over the original ice-cream parlour on St Helen's Road.

Initially the recipe included cornflour but after the war it became an all-dairy product, using a blend of five different types of Welsh milk. It is an unchanging recipe and has maintained the same suppliers for many years. There are, quite naturally, many different flavours available and the Welsh Cake ice cream is a happy fusion of cultures, the history of Joe's in a cone. It is, however, a universally acknowledged truth that you should judge an ice-cream manufacturer by the quality of his vanilla. Joe's is peerless.

There are three outlets in Swansea for this finest of cold comforts. The queues that stretch away in St Helen's Road and in Mumbles, both for tables in side and at the takeaway hatch, always reassure you that nothing has changed.

There are now parlours in Llanelli and near Roath Park in Cardiff – which just goes to show that missionary work takes many forms. When the branch in Cardiff opened, it offered customers a free ice cream. The only other time that has happened was when Joe himself handed it out on VE Day in 1945. The people of Cardiff do not know how privileged they are.

Enjoy a sundae on Sunday at Joe's.

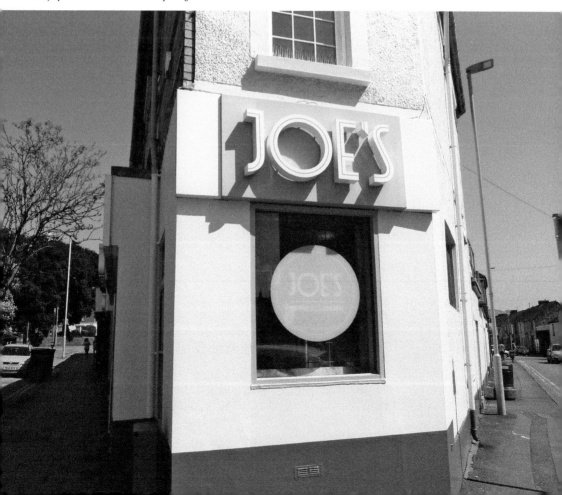

44. The Guildhall, 1934

Swansea's Guildhall is a distinctive building close to the sea and Mumbles Road. During the Second World War German planes used it to orientate themselves during daylight raids but, although the council requested money to paint it in camouflage shades, the government refused to do so since it would be impossible to hide it whatever they did. They were right – isn't a building that should be hidden. Rather it should be celebrated as the most important building in Wales of its period.

It was built to solve accommodation issues in the old Guildhall in Somerset Place, now the Dylan Thomas Centre. The architect who won the competition to design it in 1929 was Percy Thomas of Cardiff and the projected cost was £300,000, some of which came from a government fund to help relieve unemployment. It was built of Portland stone using 2 acres of land in Victoria Park, and the foundation stone was laid in May 1932. It was opened by the Duke of Kent in 1934.

Since then it has been central to the civic life of Swansea, housing law courts, the registry office, municipal offices and, of course, the Brangwyn Hall. It has a second-hand organ, obtained from the Nottingham Elite Picture Theatre, reputed to be one of the loudest in the country, though the acoustics are so good such power is not required. In 1936 Sir Thomas Beecham described the Brangwyn as one of the finest concert halls in Europe, and of course, in the hall you can find the famous Brangwyn Panels.

Undated postcard of Swansea Guildhall.

Above left: Viking longboats emerge from the clock tower.

Above right: South entrance.

This is a series of sixteen large panels celebrating the richness of the British Empire, rejected by the House of Lords for being too flamboyant but which found a home in Swansea once the height of the hall was raised to 13 metres to accommodate them.

Above the main entrance is the Central Clock Tower, 48 metres tall. If you look to the top you can see emerging from it the prows of Viking longboats, celebrating the origins of the town. Inside there are excellent interiors including a grand staircase. It is no surprise that it has been used as an occasional location for *Doctor Who* episodes and for scenes in the 2016 film *Their Finest.*, for when you go inside you are transported to an elegant past.

45. Swansea Market, 1961

It is the market that gives the city a genuine sense of individuality. The largest indoor market in Wales remains at the heart of Swansea life. There is nowhere else quite like it. Just look at the Cockle Rotunda. Where else could you find such a generous profusion of laverbread and cockles?

There has always been a market in Swansea and it has been in a number of places too. Initially next to the castle, it then moved to the top of Wind Street

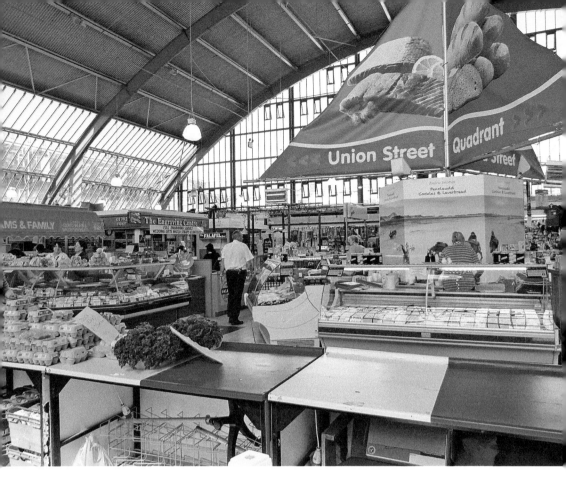

Above: Towards the Cockle Carousel.

Left: Coakley-Greene fish stall, founded in 1856 (photographed in 2018).

where it was sandwiched between Butter Street to the east and Potato Street to the west. A new larger market was opened in September 1830 on Oxford Street and has occupied the same site ever since right in the heart of the town, with entrances on all four sides. It was further developed in 1897 when an impressive façade was added and the whole space was enclosed by a wonderful glass and wrought-iron roof. By the 1920s it accommodated almost 600 stalls.

Sadly the delicate lattice work of the roof was destroyed in the Blitz of February 1941. However, the spirit of the market could not be extinguished and it continued to trade in the open air. Conditions were far from ideal though, with serious sanitary and hygiene issues. There was an undimmed commitment across the town to sustain the market but there were long discussions throughout the 1950s about where it should be and what it should be like. There was a suggestion that it should be on three levels to include a concert hall plus an underground car park, which would double as a public air-raid shelter in the event of a nuclear attack (a feature that would have generated government subsidies).

Eventually the rebuilt market, minus its fine façade (and any sort of nuclear bunker) and enclosed now, not by a wall but by shops, was eventually reopened in May 1961. A brass band played, traders from Gower appeared in full Welsh costume and their oldest member, Margaret Phillips from Llanmorlais, who was eighty-four, presented flowers to the mayor. It was, as the *Evening Post* proclaimed, 'A Proud Day for the Town'.

46. Plantasia, 1990

Plantasia provides Swansea with an unexpected and exotic window into a completely different environment. This huge public hothouse, erected in 1990 in Parc Tawe on Quay Parade, is a pyramid constructed from metal frame and glass, with a lush profusion of plants within. There are two different zones, with their climates controlled by a computer connected to a weather station on top of the roof. One is an arid zone and the other is a tropical rainforest. There is animal life too: fish, birds, insects and a colony of Tamarin monkeys were rehoused here following the closure of a local wildlife park.

The facility promotes environmental awareness and responsibility and obviously has an important educational function. It is very popular with schools that appreciate the way in which it provides a context for examining important issues. There are always activities here, including art and poetry workshops. One of the most popular features is the rainforest hut, installed in 2011 and made from traditional materials, such as bamboo and reeds. In the background, tribal music, recorded on location, adds an authentic atmosphere, though there is no escape from Plantasia's angular modernity. It is no surprise that it is used as a film location and by families looking for an interesting way in which to pass a wet afternoon.

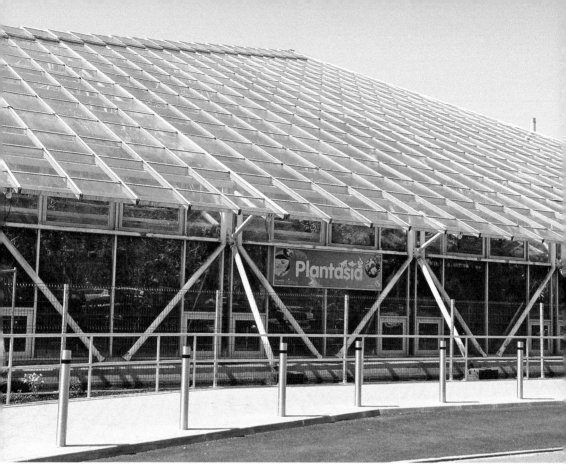

Plantasia.

47. Verdi's, 1993

The story of Verdi's begins at the end of the Second World War, in the beautiful province of Parma in northern Italy. Joe Moruzzi was like so many others who left villages like Bardi and arrived in South Wales in pursuit of a better life. After running a small kiosk selling ice cream, he opened a much-loved chip shop in Ravenhill. Eventually the family went back to Parma to open a coffee shop there, and it was in conversation with his regular customers that someone had a bright idea. 'Let's all go to Swansea,' they said. 'Let's build a coffee bar,' they said. Verdi's was born, named after the region's greatest son, the composer Giuseppe Verdi.

The building was designed by one of the customers, Signor Braglia, and you can see his signature, a motif of a circle within a square, on the lovely latticed steel beams and on the steel pedestals of the tables.

The structure was designed and fabricated in Parma before being shipped over to Mumbles in February 1993, with Italian tradesmen to weld the steel beams, to supervise the overall construction, to paint and to tile. The triple-layered sheets of glass, which open up fantastic views across the bay, were Italian too.

Verdi's is formed of rectangular modules, the frames set in immoveable concrete, ideal for such an exposed position. Plenty of maintenance is required to hold back the corrosive effect of seawater, especially on the copper gutters and roofs.

It opened on 6 July 1993 to some initial hostility because of its position on the foreshore, but it was soon realised that it was bringing families to Mumbles and so improving business. It has as many as eighty employees during the busy summer months, serving 115 tables. They are frequently full.

They naturally make their own ice cream and the restaurant uses authentic Parma ingredients, brought three or four times a year in giant lorries, including pasta, flour, cheese and ham. They also use local Welsh produce and they have their own bakery in Fforestfach.

Right: Verdi's motif.

Below: At Verdi's. (Photograph reproduced with the kind permission of Verdi's)

Guiseppe Verdi goes for coffee. (Original illustration by Jason O'Brien, reproduced with kind permission)

Verdi's is a taste of Italy in Mumbles and one of Swansea's perfect places on a warm summer's evening. It is impossible to imagine Swansea without it.

48. The Liberty Stadium, 2005

It is the home to Swansea City Football Club, the Ospreys Rugby Team and a popular car boot sale. It is a striking building that has been an important part of the regeneration of the Morfa, a part of the city once scarred by some of the worst industrial pollution in Europe. Instead of a black poisoned valley, there is a gleaming white modern stadium, encased in a steel web of supports, which dominates the Lower Swansea Valley. It is a structure of which so many people are proud.

Above: The Liberty Stadium.

Below: Practice session, 2018, prior to a match with Chelsea FC.

The historical significance of the site was recognised during the construction when it was known as 'White Rock', the name of the copper works that once stood close by. Sadly history carries little financial leverage in a brave world of sponsorship, and the naming rights were awarded to Liberty, a development company. The Liberty Stadium opened in July 2005.

The stadium was built on the site of the Morfa athletics stadium and cost £27 million, as part of an overall development with the retail site next door. It has a capacity of about 21,000 and has become a venue for parties, conferences and concerts. There is a frequently expressed desire to increase the capacity of the stadium, but of course future planning in an area as uncertain as sporting success can be fragile.

There has been some controversy about the funding arrangements for the Liberty Stadium, which were questioned by the European Commission during an inquiry into state aid for sports clubs. Both Swansea City and the Ospreys have been tenants, paying a nominal rent to a management company. However, in 2017 the council agreed to lease the stadium to them.

Outside the stadium there is a statue of Ivor Allchurch, 'The Golden Boy' of Swansea football, which was erected in October 2005. He was discovered playing schoolboy football at nearby Cwm Level and eventually made his league debut in the 1950–51 season. In two spells with the club he made 445 appearances and scored 164 goals, playing sixty-eight times for Wales. He eventually ended his playing career at Pontardawe Athletic in 1979, at the age of fifty.

49. The Meridian Tower, 2009

The architects describe the tower on the Meridian Quay as 'a beacon signalling the rejuvenation of Swansea'. It is certainly a beacon. At the time of writing it is the tallest building in Wales, standing at 107 metres. It is a twenty-nine-storey apartment block with the top three floors given over to a restaurant with spectacular views. The menu suggests that it has been inspired by the land and the sea. Perhaps it should have been inspired by the sky. There is plenty that surrounds it.

The Meridian Tower was designed by Latitude Architects and built by the Carillion Company at a cost of £40 million. Tragically, a worker died in a 62-foot fall during the construction, when he fell while dismantling scaffolding platforms, a result, a court found, of negligence by subcontractors. The building was ceremonially 'topped out' in September 2008 after five years work and opened in 2009. There are 291 residential units, commercial space at ground level and two underground car parks. It has become Swansea's newest and most popular landmark. A town that has spread around the bay for centuries now spreads upwards.

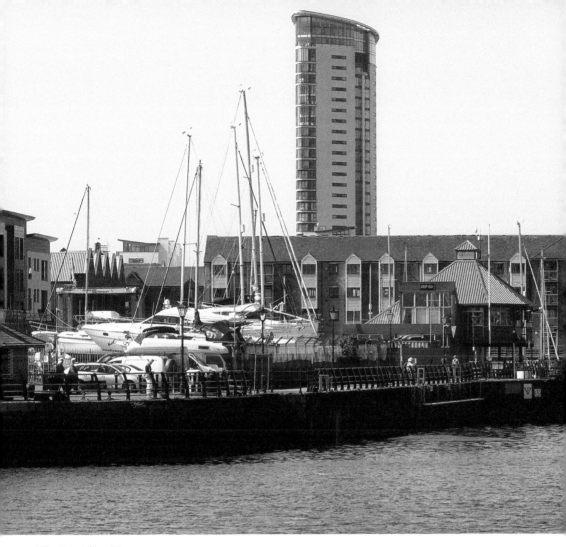

The Meridian Tower.

Of course, its status brings with it certain problems. A man wishing to commit suicide held people hostage in the restaurant with an imitation handgun in 2014. The situation was resolved by the use of a taser. There was also a kitchen fire on the second floor in 2017, which led to an evacuation. Perhaps this is the price you must pay for living in the sky.

Despite such inevitable vulnerabilities, however, it remains a sought-after address and certainly dominates the whole of Swansea Bay. A dedicated swift lift will shoot you up to the twenty-eighth floor to the Grape and Olive restaurant where the views are spectacular and every customer seems to have brought their camera so they can record the time when they seemed to soar like a seagull, above the city and above the bay. Every time you go there, what you see will be subtlety different as the seasons, the weather and the time of day changes. It is a spectacular and welcome addition to the city.

Detail of the Meridian Tower.

50. Cob Isaf (the Down to Earth Project), 2011

Down to Earth is an innovative training centre that was established in 2006 in a beautiful valley in Murton, above Caswell Bay. Outdoor learning experiences are used to help learners change themselves and their communities by developing new skills, which build self-confidence and promote self-awareness.

The project is a not-for-profit social enterprise that employs traditional and sustainable building methods using local materials on a number of sites across South Wales. At the heart of its work is sun-centred design, providing heat and light, and rainwater harvesting. It is extremely successful in engaging with school groups, which might sometimes be described as hard to reach or disaffected, and at Murton there is an emphasis on supporting adult groups, which might include patients recovering from brain injuries, domestic violence victims or the homeless. The project continues to work with health professionals on clinical studies, which show that the opportunities provided are more beneficial in improving mental well-being than anti-depressants. In soothing tranquil beauty troubled people can exchange the distractions of over-stimulation and their chaotic lives for birdsong.

Above: Cob Isaf.

Below: Inside Cob Isaf.

Satisfyingly crunchy cockle paths will lead you to Cob Isaf, which could be a portal to a fairy tale. Designed by the Down to Earth team, it is the perfect illustration of their commitment to showing how new technologies and traditional techniques can work so well together. It is made from cob – a traditional material made by binding together straw and crushed stone using clay-rich subsoil. There is a living roof, the walls gentle not angular and a suspended larch gutter. Harmonious is the only word you can use. However, within Cob Isaf you will find broadband access delivered through the electricity cable itself, which is fed by a bank of ground-mounted photo-voltaic cells, the first to be installed in Swansea.

Cob Isaf is a happy union of past and present and the best place, I think, to finish our tour through Swansea's architectural heritage. It represents a place that rejects wasteful innovation and instead reaffirms traditional values; a place that illustrates, more than any other, the indissoluble link between man and the environment.

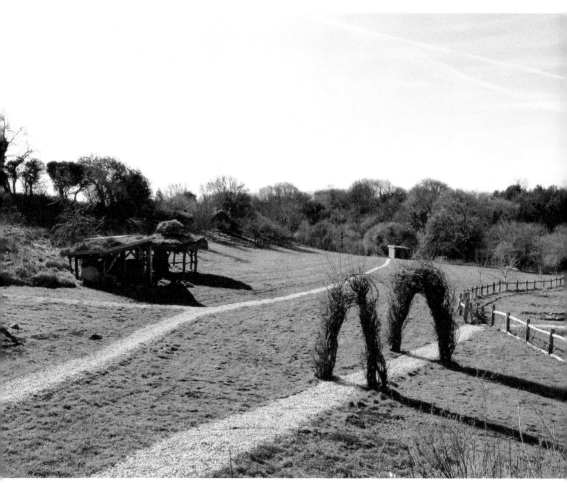

A cockle shell path leads to Cob Isaf.

Acknowledgements

A great deal of what I have written has been supported by an army of unnamed journalists who wrote about Swansea as they saw it in the local press throughout the nineteenth century. To them I owe my greatest debt of gratitude.

Giuseppe Gianciarulo, part of the original construction team from Italy, is now general manager of Verdi's, and I am grateful for the time he gave me to talk about the origins of the business. I should also like to thank Dr Sean Jenkins, who gave me access to the beautiful reading room at the Central Library, David John, who provided me with access to photograph the magnificent interior of Morriston Tabernacle, and Lynne Vaughan, who arranged for me to photograph the unexpected fireplace in Singleton Abbey.

I would also like to thank David Brookes, Melanie Heath, the Dylan Thomas Birthplace, Joe's and Verdi's who helped by providing important photographs.

Any mistakes that the book contains are all my own.

About the Author

The author's connections with Swansea were established initially by marriage and then by profession. He began work as the Head of English in Dillwyn Llewelyn Community School in 1981 before moving to another of Swansea's Community Schools, Cefn Hengoed, as Deputy Head Teacher, where he worked for twenty years until his retirement in 2011.

His writing career began with occasional columns in the education pages of *The Independent* and more regularly for *The Times Education Supplement.* He was short-listed as Columnist of the Year (Business Media) at the Professional Publishers Association awards in June 2011 for his work with TES. He has written books on educational management, dyspraxia and a number of GCSE study guides for English Literature candidates. He has a regular feature in *Welsh Country Magazine*, writing about Welsh gravestones and the secret stories they contain.

Geoff Brookes has previously written two books for Amberley Publications about Swansea: *Swansea in the 1950s* (2015) and *A–Z of Swansea* (2016). His most recent works (2018) for Amberley have been two illustrated guidebooks: *50 Gems of South West Wales* and *50 Gems of Mid Wales.*

He is married to Liz, a retired midwife. They have four children and eight grandchildren.